BISON BOOKS

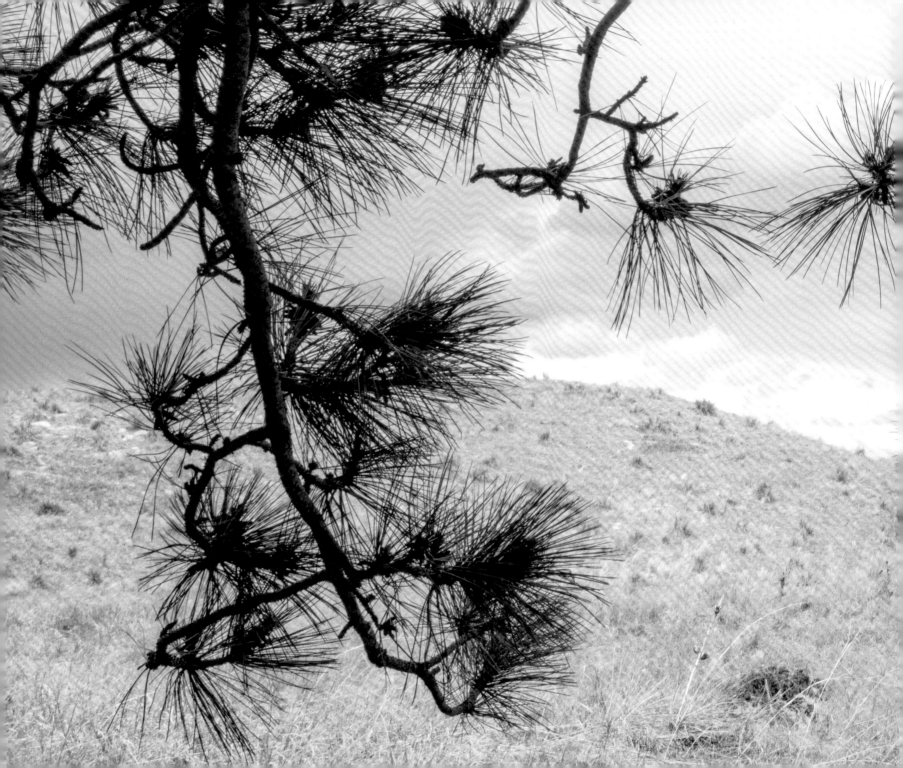

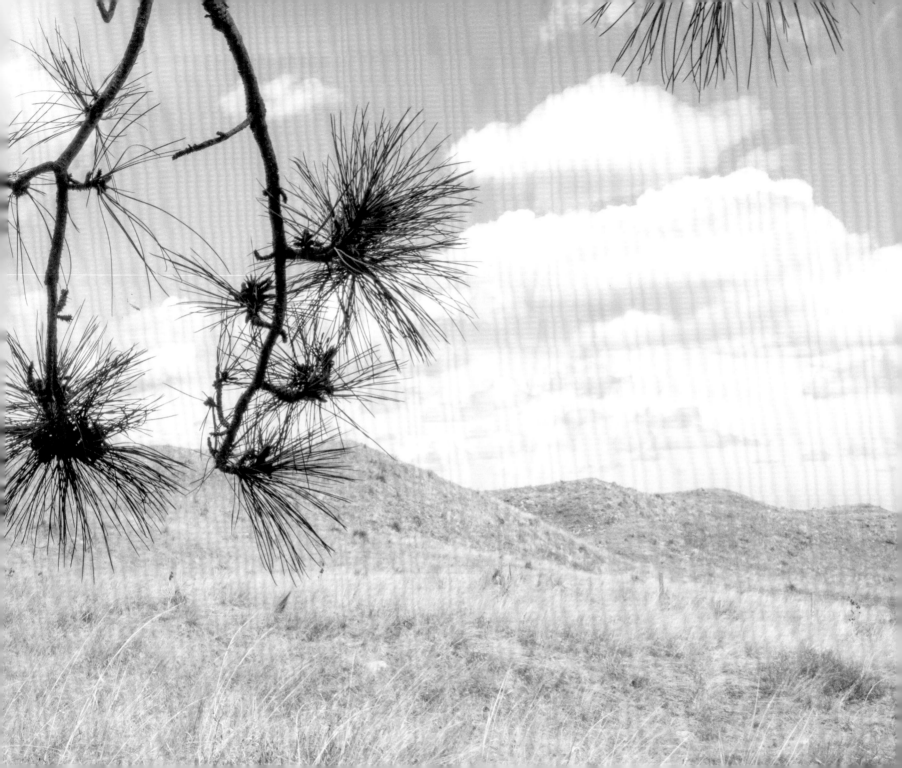

FIELD GUIDE TO A

HYBRID LANDSCAPE

PHOTOGRAPHS BY DANA FRITZ

ESSAYS BY Katie Anania, Rebecca Buller, and Rose-Marie Muzika | MAPS BY Salvador Lindquist

UNIVERSITY OF NEBRASKA PRESS LINCOLN

The University of Nebraska Press is part of a land-grant institution with campuses and programs on the past, present, and future homelands of the Pawnee, Ponca, Otoe-Missouria, Omaha, Dakota, Lakota, Kaw, Cheyenne, and Arapaho Peoples, as well as those of the relocated Ho-Chunk, Sac and Fox, and Iowa Peoples.

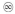

All photographs by Dana Fritz except where noted. Time line photographs courtesy U.S. Forest Service archives. All maps created by Salvador Lindquist.

Publication of this volume was assisted by Furthermore: a program of the J. M. Kaplan Fund. Publication of this volume was also assisted by the Arts & Humanities Research Enhancement Program at the University of Nebraska–Lincoln.

Library of Congress Control Number: 2022019485

Set and designed in Sabon Next by N. Putens.

CONTENTS

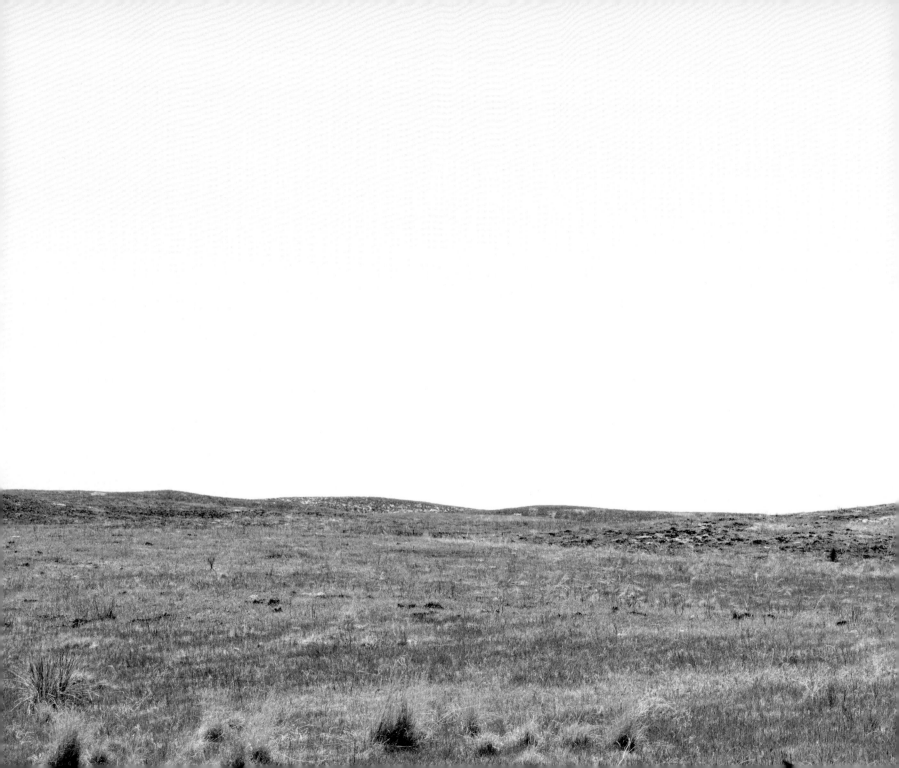

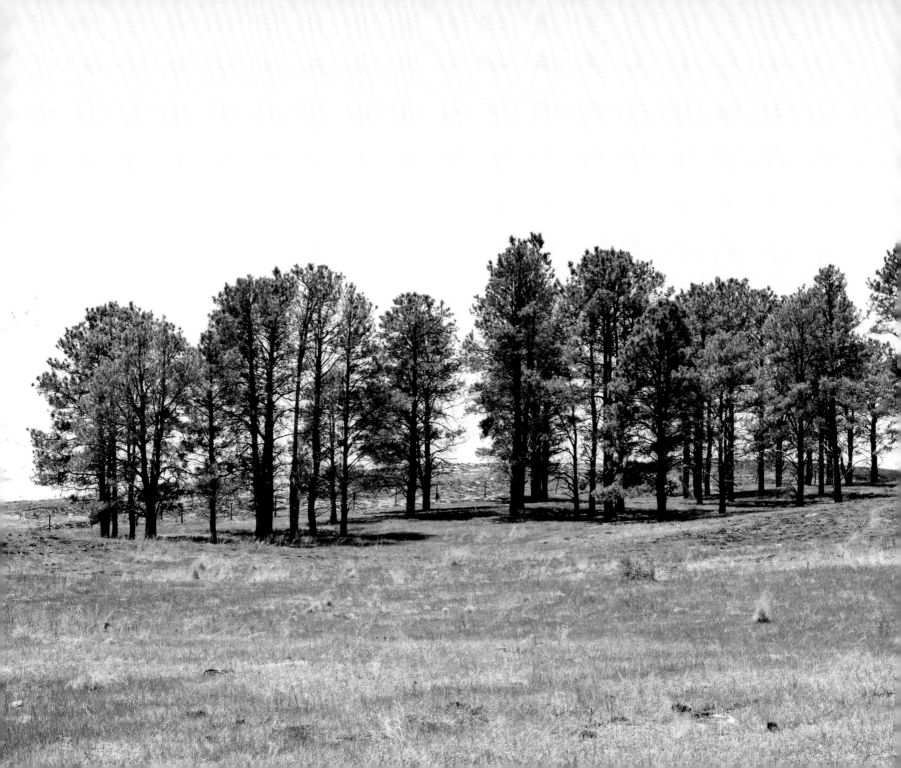

PREFACE

DANA FRITZ

Traveling the route west-northwest out of Lincoln to Halsey, Nebraska, I pass through the tree-lined streets of the capital city founded at the western reaches of the tallgrass prairie ecoregion. The state that at the time of white settlement was 97 percent grassland is now largely plowed for agriculture, due in part to U.S. federal government policies that favored the dispossession of Indigenous land and promoted homesteading. Except in the riparian areas along the route, trees appear less and less frequently but they are more organized and intentional when they do, neatly planted at farmhouses and along fields as windbreaks. A few miles after crossing the 100th meridian a great mass of trees is suddenly visible on the horizon, rising from the undulating waves of the Nebraska Sandhills, an area of mixed-grass prairie that was once described as part of the "Great American Desert." This puzzling landscape, containing a twenty-thousand-acre forest in a sea of grass-stabilized sand dunes, was conceived by Charles E. Bessey in the 1880s, during an era of widespread industrial deforestation in the east and when Nebraska became known as "the Tree Planters' State." This hybrid landscape is now the Bessey Ranger District and Nursery of the Nebraska National Forests and Grasslands. This planted forest is one of the rare disrupted parts of the largest intact temperate grassland on the planet.

P1. *Riparian Area, Shelterbelts, and Planted Forest.* Dana Fritz, 2021.

Dr. Bessey joined the faculty at University of Nebraska as a professor of botany and his legacy is strongly evident: in Bessey Hall on the Lincoln campus, in the Charles Bessey named professorship of the university, and in the Bessey Herbarium at the Nebraska State Museum, which holds more than three hundred thousand specimens and is one of the oldest and largest in the Great Plains. Often considered the father of modern botany, Bessey also served as acting chancellor and, when the legislature wanted to divide them, insisted *three* separate times that the land grant university and the state university remain one institution that educated in the sciences *and* the arts. I am grateful to Bessey for making my art faculty position possible and for his influential work in the taxonomy of plants that has informed the countless field guides published since his tenure.

Upon learning about what Bessey proclaimed was the "greatest undertaking in the tree-planting line that was ever attempted in this country," I immediately wanted to know what trees were planted in this grassland forest. Botany professor and member of the Citizen Potawatomi Nation Robin Wall Kimmerer writes that names are the way we humans build relationships, with each other, and with the living world. I longed for a formal introduction to this hand-planted forest, but no field guide to this particular intersection of biomes yet exists.

I scoured traditional field guides describing forests and grasslands, which provided names, images, and descriptions, but these facts left me wanting more. I longed to understand not just what this forest contained but how it came about and how it functions today. Through further research I began to grasp that this discrete plot of forested land is what feminist scholar of science and technology Donna Haraway might call "tentacular," because it has limbs in history, agriculture, speculation, science, law, recreation, and evolving ideas about climate change. I set out to build a relationship with this dynamic and curious place through photography, framing and reframing the elements and processes that contribute to its unique condition. From the shoulder of Highway 2, the hiking trail, the fire tower, the riverbed, the campgrounds, the forest floor, the open grasslands, the shifting dune, the fire scars, the greenhouses' interiors, the deep-sand roads, and the airspace overhead, I composed views and thoughts for five years.

This book is my field guide to a hybrid landscape, and where a traditional field guide might simplify, this one complicates.

P2. *Pinus ponderosa (rock pine), collected Dismal River Nursery, Thomas County, NE, April 1906.* Photo courtesy Charles E. Bessey Herbarium, University of Nebraska State Museum, University of Nebraska–Lincoln.

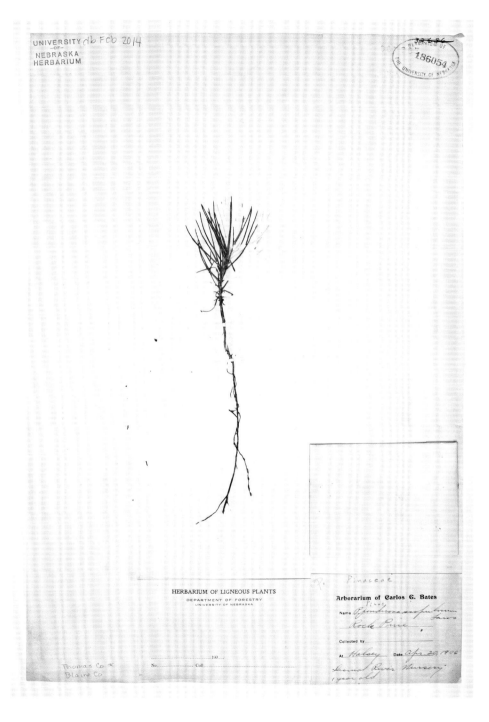

The term *hybrid* refers to something that is *purposefully mixed* and has origins in the Latin *hybrida*: offspring from a *tame* sow and a *wild* boar. This purposeful mixture of forest and grassland is a defining characteristic that echoes the concept of combining the tame with the wild. Historian Robert Gardner describes this novel biome as a technological forest that is both planted and self-sowing, managed and self-regulating. It combines human culture (labor, technology, science) with nonhuman "nature" (soil, climate, plants, animals.) Even the long-standing national forest principle, "Land of Many Uses," prescribed hybridity by simultaneously managing for timber, grazing, and recreation. But this guide is also a hybrid: part photobook, part atlas, part environmental history, part speculation. It could not have been made without field visits, but its best use is not in the field.

To organize the photographs I created a taxonomy of the forces shaping the hybrid landscape: sand/wind/water, planting, thinning, fire, decomposition, and sowing. Each branch begins with a commissioned map and a photograph from the U.S. Forest Service's archives, followed by a series of my contemporary photographs that reveal those forces. Underscoring the hybrid nature of the

system, I use noun forms for ecological elements and processes (sand/wind/water, fire, decomposition) and verb forms for human management (planting, thinning, sowing.) Essays by Katie Anania, Rose-Marie Muzika, and Becky Buller expand and connect the complex environmental history of this hybrid landscape through feminist, art historical, geographical, speculative, and ecological lenses. Maps and a time line by Salvador Lindquist visualize disparate geographical and cultural data, providing orientation in time and space.

The Nebraska National Forest's 120th anniversary marks an opportune time to examine its environmental history and relationship to climate change. Conceived when it was widely believed that "rain followed the plow" and that trees could ameliorate an unfavorable dry and windy climate, this forest was planted in order to *change the local climate*. In the twenty-first century the U.S. Forest Service has been increasingly concerned with large-scale human-caused climate change and is more aware of the role that forests and grasslands play in carbon sequestration and ecological stability. Today the Bessey Ranger District of the Nebraska National Forests and Grasslands, along with the onsite Bessey Nursery, works toward land

and water conservation, grassland restoration, and reforestation in native forest areas devastated by climate change–driven wildfires and beetle infestations. While the story of what was once the world's largest hand-planted forest is a point of pride for many Nebraskans, *Field Guide to a Hybrid Landscape* offers a critical examination and a case study of this uniquely managed landscape that has implications far beyond its borders.

P3. *Windmill and Tank.* Dana Fritz, 2017.

FIELD GUIDE TO A HYBRID LANDSCAPE

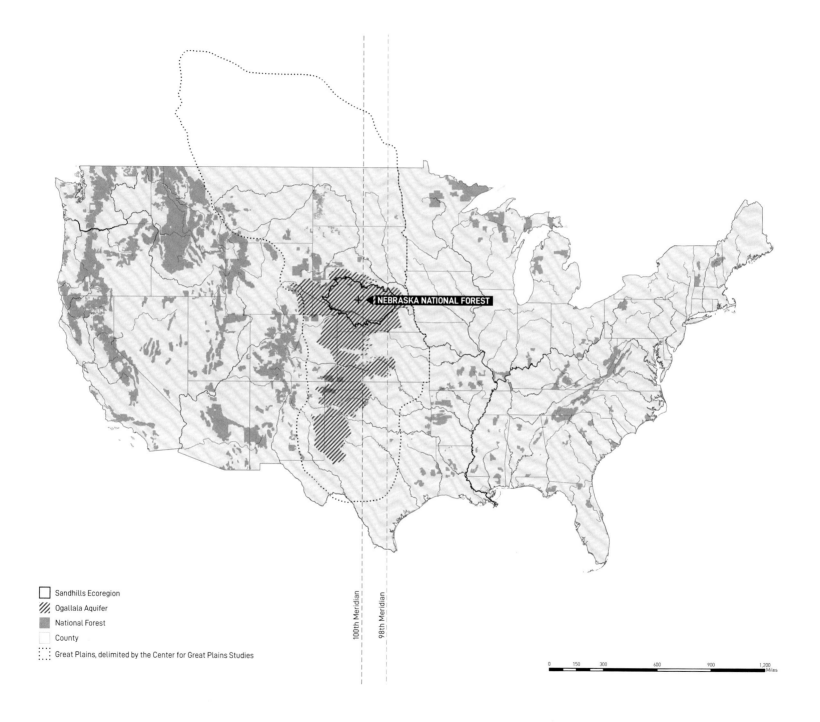

NEBRASKA NATIONAL FOREST

Sandhills Ecoregion

Ogallala Aquifer

National Forest

County

Great Plains, delimited by the Center for Great Plains Studies

100th Meridian

98th Meridian

0 150 300 600 900 1,200
Miles

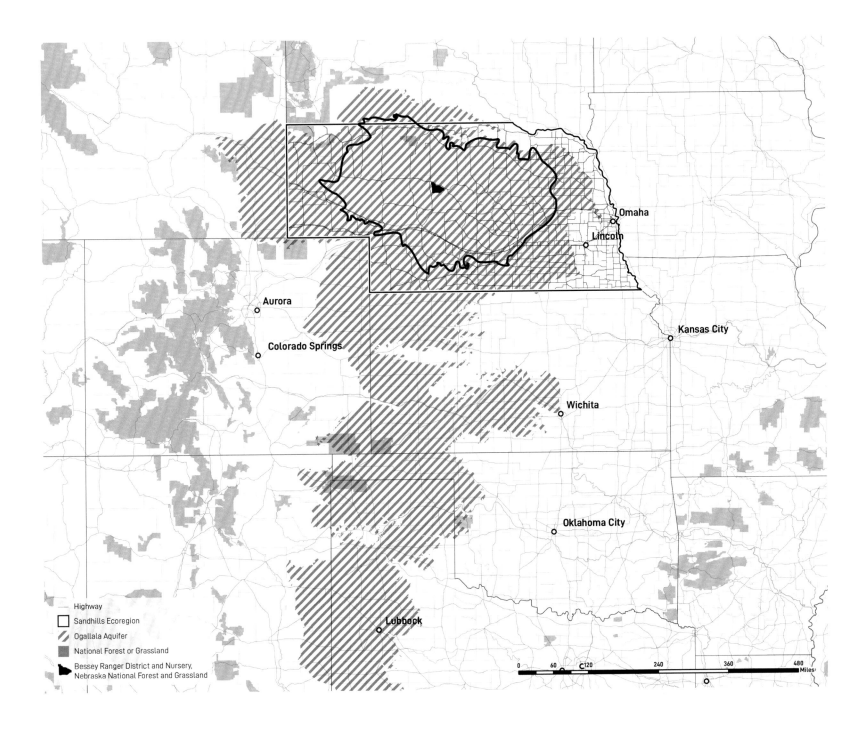

Highway

Sandhills Ecoregion

Ogallala Aquifer

National Forest or Grassland

Bessey Ranger District and Nursery,
Nebraska National Forest and Grassland

Aurora

Colorado Springs

Lubbock

Omaha

Lincoln

Kansas City

Wichita

Oklahoma City

0 60 C 120 240 360 480
Miles

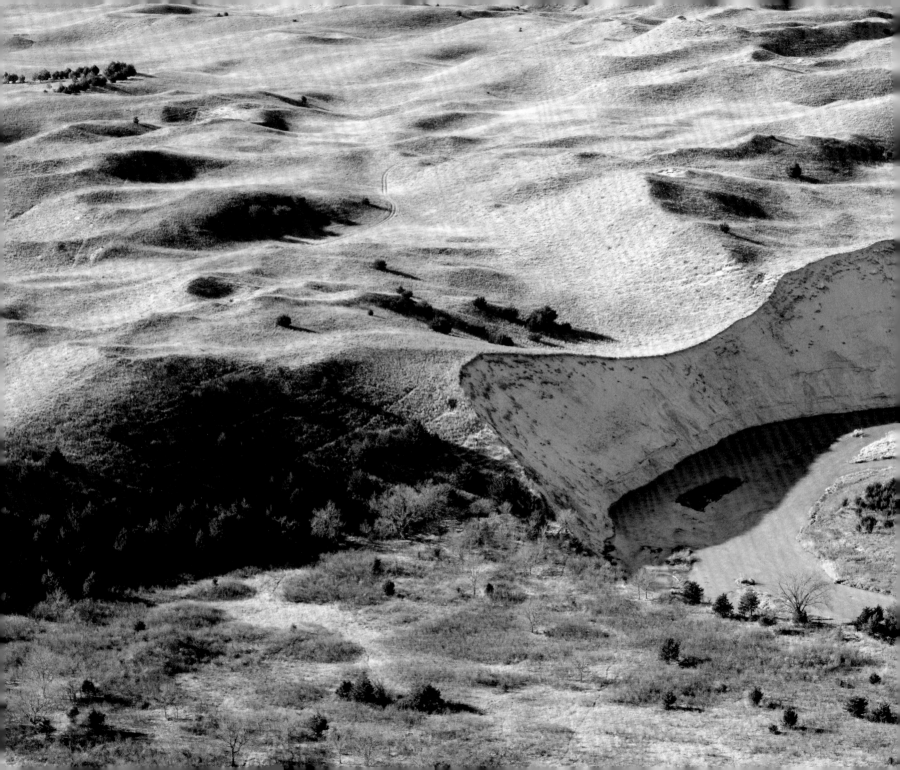

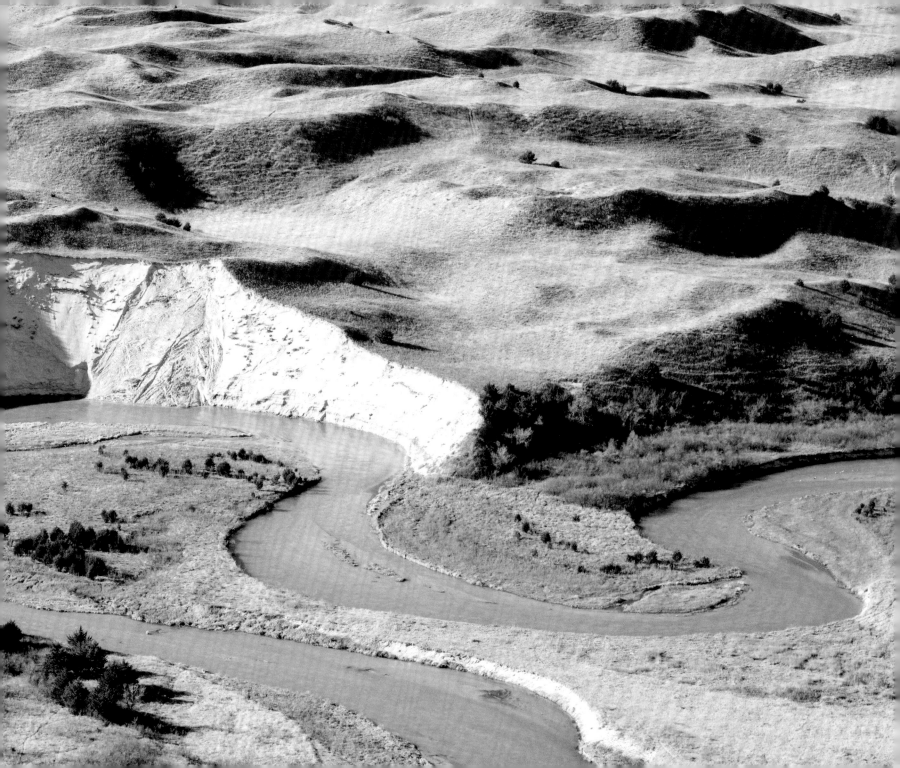

Seed block in Dismal nursery

Plowing Sandhills with horses

1800 1810 1820 1830 1840

1100-1400
◄ Pawnee living along the
Loup and Republican
Rivers (earliest evidence
of settlement)

1833
First white settlers in
Nebraska (Bellevue)

Jack pine stump held by man

Lookout in Scott Fire Tower

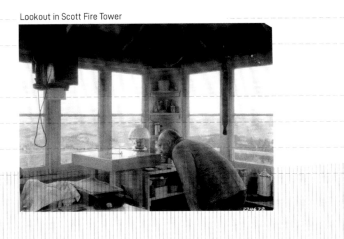

2.4m
2.2m
2m
1.8m
1.6m
1.4m
1.2m
1m
.8m
.6m
.4m
.2m

1850

1860

1870

1880

1890

1900

1854
Nebraska territory incorporated

1857
Pawnee Treaty of 1857

1862
Homestead Act gave citizens or future citizens up to 160 acres of public land provided they live on it, improve it, and pay a small registration fee.

1863
First homestead established near Beatrice

1867
Nebraska Statehood

1869
Transcontinental railroad completed

1872
Arbor Day established in Nebraska City

1873
Timber Culture Act allowed homesteaders to get another 160 acres (65 ha) of land if they planted trees on one-fourth of the land

1875
Pawnee Reservation created (last land ceded)

1876
The Office of Special Agent for forest research is created in the Department of Agriculture to assess the state of the forests in the United States.

1890
Bessey urges federal government to plant trees in Sandhills

1891
The Forest Reserve Act of 1891 authorizes withdrawing land from the public domain as "forest reserves," managed by the Department of the Interior.

1891
Hatch Act establishes funds for agriculture experiment stations

1891
Bessey establishes test plot for growing trees in Holt County on Bruner Ranch

1895
Nebraska became known as the "Tree Planters" state.

1902
Dismal Forest Reserve established

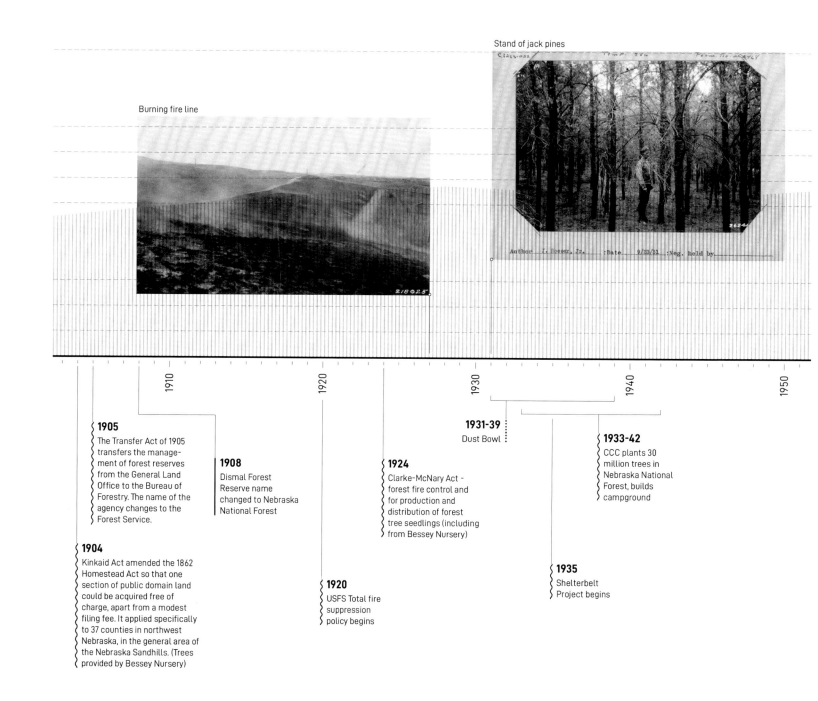

Burning fire line

Stand of jack pines

1910　　1920　　1930　　1940　　1950

1905
The Transfer Act of 1905 transfers the management of forest reserves from the General Land Office to the Bureau of Forestry. The name of the agency changes to the Forest Service.

1904
Kinkaid Act amended the 1862 Homestead Act so that one section of public domain land could be acquired free of charge, apart from a modest filing fee. It applied specifically to 37 counties in northwest Nebraska, in the general area of the Nebraska Sandhills. (Trees provided by Bessey Nursery)

1908
Dismal Forest Reserve name changed to Nebraska National Forest

1920
USFS Total fire suppression policy begins

1924
Clarke-McNary Act - forest fire control and for production and distribution of forest tree seedlings (including from Bessey Nursery)

1931-39
Dust Bowl

1935
Shelterbelt Project begins

1933-42
CCC plants 30 million trees in Nebraska National Forest, builds campground

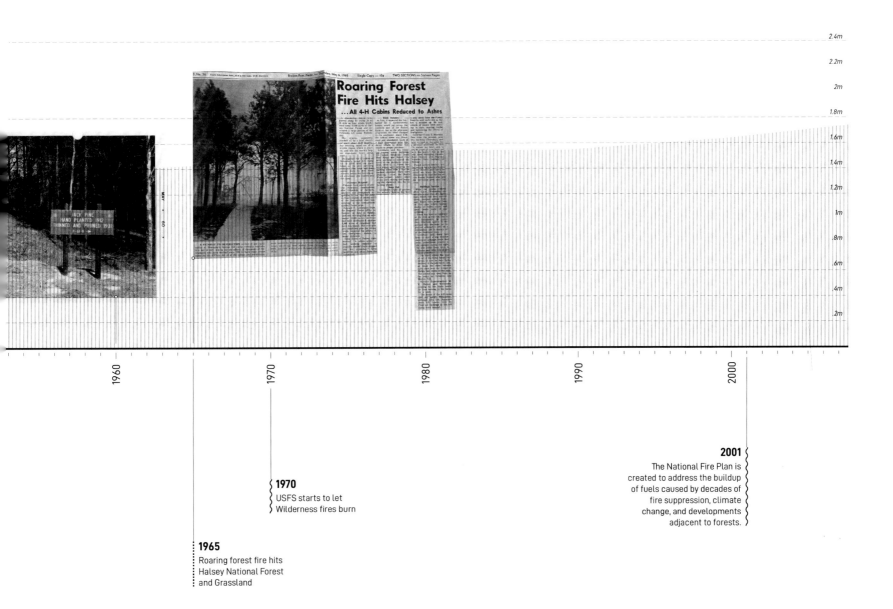

2.4m

2.2m

2m

1.8m

1.6m

1.4m

1.2m

1m

.8m

.6m

.4m

.2m

1960

1970

1980

1990

2000

2001
The National Fire Plan is
created to address the buildup
of fuels caused by decades of
fire suppression, climate
change, and developments
adjacent to forests.

1970
USFS starts to let
Wilderness fires burn

1965
Roaring forest fire hits
Halsey National Forest
and Grassland

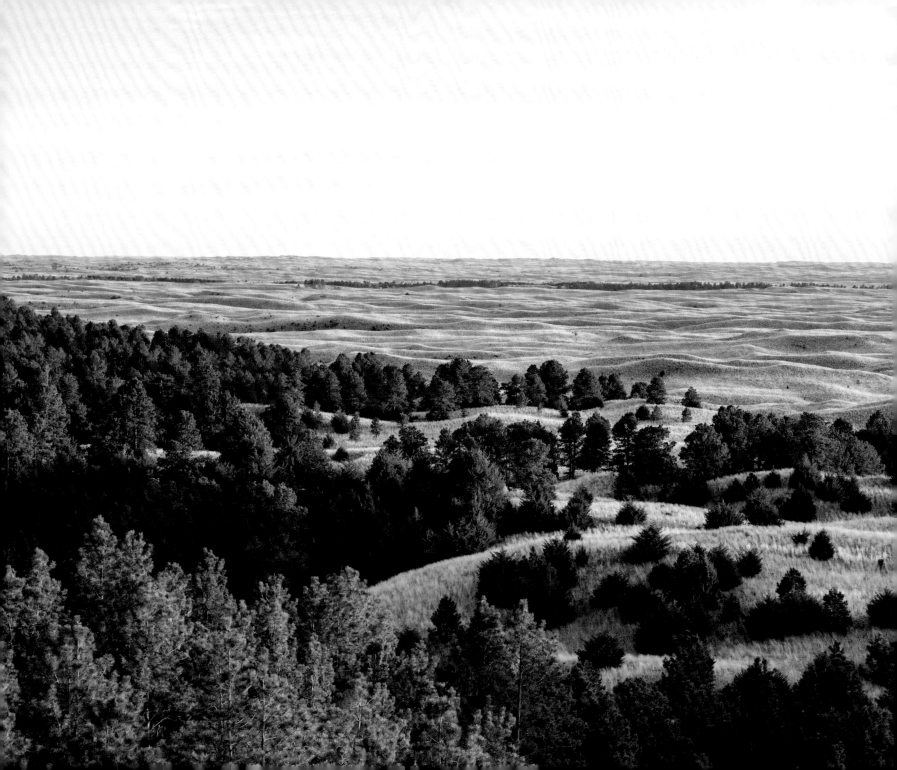

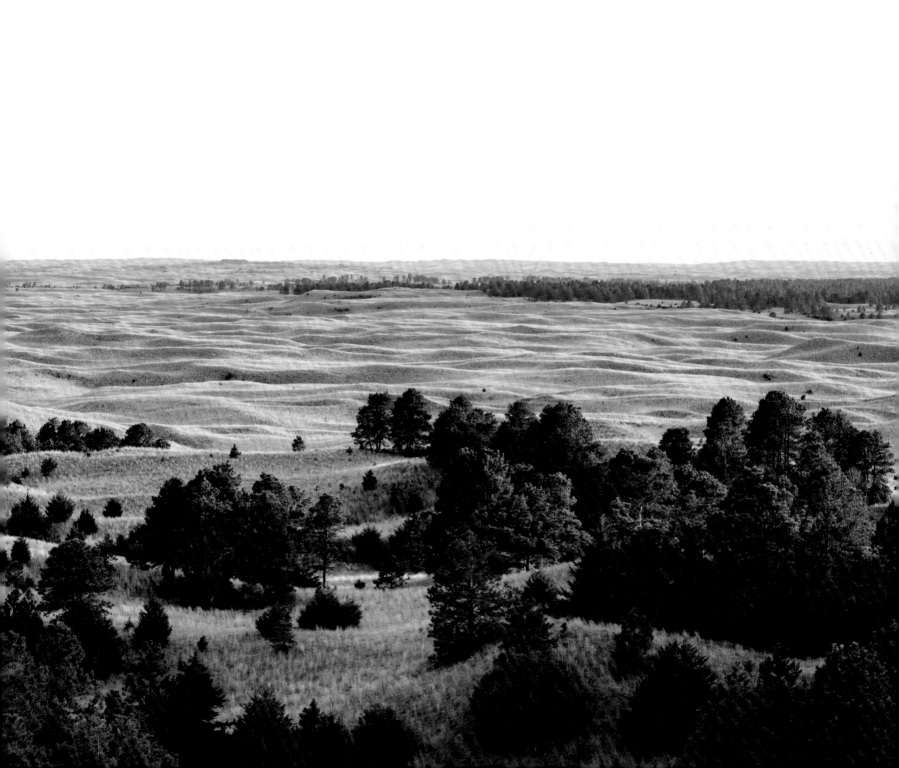

Tillage, Indigeneity, Supplementarity or: Every Treeless Horizon Wants to Thrive in Peace

KATIE ANANIA

Once we recognize that looking is complicated, reframing becomes easy. If we look long enough at images and maps of the Nebraska National Forest, they will lay bare an enormous variety of histories—of cultivation, of conflict, and of theft. This can mean that the slightest change in the framing of the camera, or a change of focus—both inherent to lens-based media, both of which loosen the boundaries of narratives written and maps drawn—will pull us into multiple histories at once. For instance: after learning about U.S. president Theodore Roosevelt's decision in 1902 to set aside over ninety thousand acres of sandhill prairie in Nebraska to be converted into a treed forest, we might train our lens instead on the long-tended Pawnee and Miniconjou territories that were ceded in treaties to make way for settlement. Roosevelt's executive proclamation turned long-inhabited land into an object for improvement and productivity. Begun as a homeland but then reframed as a raw space, this prairie would spend much of the twentieth century being tilled into a vast state garden.[1]

By 1902 the young state's native vegetation and topography had become an endless source of frustration for white migrants. When the University of Nebraska broke ground in 1871, newspaper editor Julius Sterling Morton called all of Nebraska "untried land" and insisted that it could be tilled only through "the grandest of material labors."[2] The state's broad grassland seemed impervious to corn and grain cultivation, demanding heavy management right from the start. In the years following the Morrill Act of 1862 and the Nebraska Enabling Act of 1864, the new university built a model farm on campus to provide agricultural training for its working class. The state passed its first weed law in 1873, which levied a fine of ten to forty dollars on state residents who allowed Canada thistle to grow freely on their property.[3] Western Nebraska and other parts of the Great Plains region were dismissed for much of the nineteenth century as arid and underperforming—as living proof of naturalist William Darlington's assertion that "the labors of the agriculturalist are a constant struggle."[4] The problem of agricultural output became a central driver of midwestern modernity.

In truth the region's prairies teemed with botanical wonders. Big bluestem and prairie clover sprouted long cellulose stems and wove their fibrous roots into the soil, damaging farm equipment that tried to clear them away.[5] A 1902 specimen of a big bluestem in the Bessey Herbarium shows the plant's seemingly endless whorls of nodes, blades, and inflorescences compressed against a paper support (photo 6). In late summer this plant can grow to reach the height of a human head. Bison and berries also once thrived, providing protein and nutrients to travelers.[6] Still, Morton, a prosperous publishing magnate with 160 acres of appropriated land just west of Nebraska City, was determined to wage a "battle against the timberless prairies."[7]

Perplexed by Nebraska's willful biomes, Morton spent his life supplementing its landscape with trees. He recommended the creation of an "arboreal bureau" that would track the state's trees and orchards. He founded Arbor Day, a yearly (now state) holiday first held on his own birthday. Every April 22 parade floats drifted down the streets of Nebraska's cities, touting the benefits of new timber and galvanizing enthusiasm for the holiday's federal inauguration in 1973. One such picture from 1917 shows a float festooned with grape arbors and greenery, with signs that urged woodmen to leave trees untouched (photograph 7). Abundance would prevail.

P6. *Andropogon gerardii vitman (Big Bluestem), collected in Thomas County NE, November 1902.* Photo courtesy Charles E. Bessey Herbarium, University of Nebraska State Museum, University of Nebraska-Lincoln.

But abundance is often selectively perceived. The Omahas, whose name derives from the moniker U-Mo'n-Ho'n, or "upstream," had moved up and down the Missouri River for centuries, planting crops in riverside lots. The Cheyennes settled throughout the Great Plains because the region bisected the horse trade, which encouraged the establishment of a vast regional trading system. Forming alliances across geographic and agricultural spaces became an important adaptive mechanism to meet people's complete nutritional needs. But, as feminist science scholar Kim TallBear has pointed out, the binary between living and not living, between animate and inanimate, which in Western science rests "at the level of the organism," in the nineteenth century extended to land.[8] If land in the Great Plains could not support a single template of productivity and wealth expansion—a template for which timber trees became an emblem—then it was "barren."

Designations like *fertile*, *abundant*, and *barren* have feminist implications, and Dana Fritz uses her lens to invoke them. In the photographs here, tiny tree seedlings sprout in neat homogenous rows, while native grasses blow and proliferate. Occasionally the grasses obscure stretches of forest land

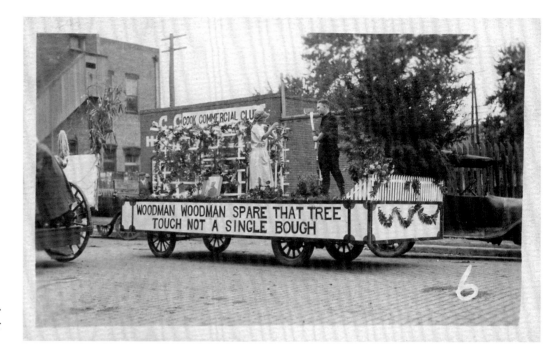

(photo 8), reversing Roosevelt's and Bessey's prized narratives about the forest's value. Trees burn, and their trunks fall over to become habitats for more animals. Sections of grassland separate treed areas meant to provide protection in case of fire.[9] It becomes clear that the very prairie that the Nebraska National Forest was designed to supplement has the same verdant, generative qualities as the forest itself.

French philosopher Jacques Derrida wrote in 1967 about supplementation and its strange logic, just as the modern environmental movement in the United States was

P7. *Arbor Day Parade in Nebraska City, 1917.* Photo courtesy History Nebraska.

P8. *Grassland Forest Ecotone.* Dana Fritz, 2019.

broadening its message to plant and protect trees. For Derrida, supplementation is more than simply adding something to something else. In adding an element to make up for a deficiency, he argues, we make many things happen. We may corrupt the integrity of the original thing even as we make up for its perceived deficiencies. The supplement may be a remedy, but it can also be a danger. Ultimately, supplementation is the act of "a plenitude enriching another plenitude"— and, by pointing this out, Derrida reveals that deficiency is an unstable and contingent concept, understood in different ways and

in distinct times and places.[10] A supplement changes things irreversibly, but it can also reveal things that were always present.

The Nebraska National Forest is a plenitude added onto another plenitude. Its many biological processes make it a fixture of multispecies survival. Its nonnative trees were envisioned by University of Nebraska botany professor Charles Bessey and others since Bessey's time, but it is this same tree nursery that is now saving other forests, with trees from the nursery supplying important botanical infrastructure to forestall soil erosion and propel healing from fires.

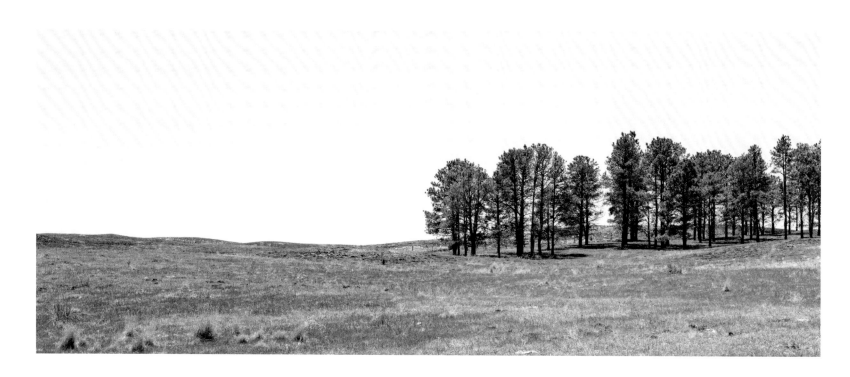

The photograph *Forest Edge* uses a panoramic landscape view to show where the Nebraska National Forest's ponderosa pine trees end and the surrounding grasslands begin (photo 9). The ponderosas do not appear to trail off, as they would at the edge of a naturally occurring forest. Instead, they seem to end abruptly—awkwardly, even—against the expanse of grass. On one hand the photograph captures a face-off between two ecosystems, two homelands, two narratives: one told by Charles Bessey and J. Sterling Morton, who envisioned verdant landscapes of the future, and a powerful network of nourishment that holds millions of organisms in place, a prairie tended for centuries by Indigenous people. On the other hand the photograph exposes the fiction of dualism: grassy ground supports the ponderosa pines and allows them to grow. Each side provides nutrients and infrastructure for the other.

In this way Fritz's work disrupts the idealizing naturalism of photographers like Ansel Adams, who conceived of landscape as a thing to be presented to the viewer with perfect clarity. For Adams, the photographer's task was to "create configurations" out of

P9. *Forest Edge.* Dana Fritz, 2021.

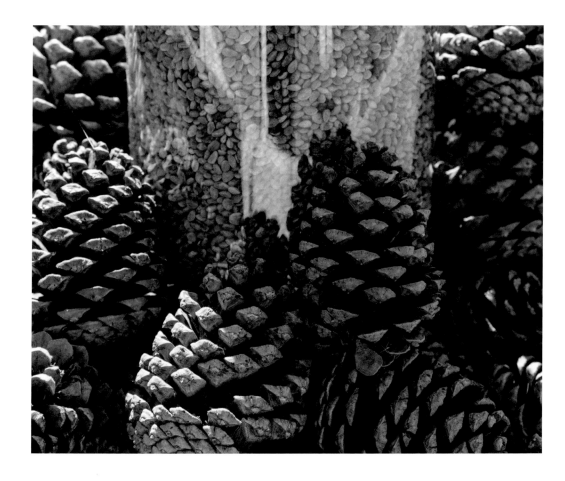

P10. *Cones and Seeds.* Dana Fritz, 2019.

nature's "vast, chaotic collection of shapes" so that they generate a sacred dialogue between photographer and viewer.[11] To frame the landscape into a single iconic image could make it into a clear target for conservation. But, unlike Adams, who uses the camera as an Enlightenment-era scientist might use a microscope, provoking the viewer to desire and preserve what is seen, Fritz's photographs provide few clear visual cues of lushness or fertility. Her framing plays up the Nebraska National Forest's variegated qualities rather than minimizing them—a very different way of calling the landscape to our attention. In certain moments the trees in the photographs look dry and strange, like a clump of livestock lumbering across the plains to feed. Throughout this field guide the signs of arcadian pleasure give way to the pragmatic details of constructed, manmade life. Nursery managers set aside pine seeds for future sowing (photo 10) or assemble seedlings inside a greenhouse. This forest is a true hybrid: it has no real natives, only stewards of strange fictions.

When rocks, tree trunks, pinecones, or people are presented to us as displaced stewards, in an elaborate web of barely belonging and making do, we begin to recognize traits in each that make them vulnerable

to exploitation. Feminist artists have long explored the political dimensions of this vulnerability, using the supplement to show how all materials have the potential to be designated as infertile, uncooperative, or needing improvement. From 1969 to 1974 Los Angeles artist Judy Chicago launched Atmospheres, a series of site-specific performances in Southern California and Nevada. From desert sites to Century City parking lots, Chicago staged live performances with colored smoke, dry ice, and fireworks, as nude female figures in body paint "colored" the landscape with bright blue, green, red, and purple vapors (photo 11). The works were intended to infuse the land with a wild, overtly decorative richness and reintroduce feminine rituals such as shamanism and midwifery back into public life.[12] In each performance the logic of supplementarity plays out in physical, political, and chemical ways; all beings throughout time have added to land what they perceive to experience as lacking. The states of ruin in our present day—fires burning across the planet; oversettlement of beach communities; exhausted life-giving waterways—stem from our desire to cultivate a beloved, abundant view.

I think of Chicago's vapors and the Nebraska National Forest's trees in much the

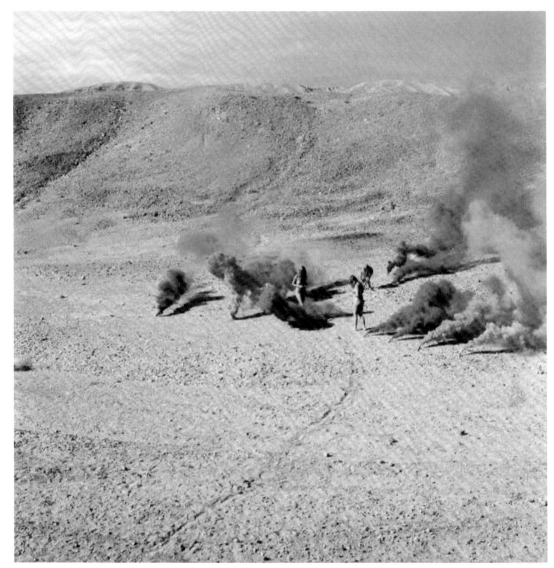

same way. Beyond augmenting the site or dissipating into it, they both reveal its inherent abundance. In founding the Nebraska National Forest, the U.S. federal government, at Bessey's urging, fused trees with good citizenship and robust scientific thinking. They imprinted on the land the potential for being filled with the right things, or at least things that would right the inherent wrongs of Nebraska's native grasslands. Communal reforestation programs have since been established through national arbor days—in China and other majority world nations—as a nationalist statement about the modern citizen's ability to manifest ecological stability, mirroring the actions of organizations like the Boy Scouts in the United States.[13] That Chicago's vapors feel grander and more magical is a tribute to her ability to make us see how imagination works on land and territory.

The photographs in *Field Guide to a Hybrid Landscape* enact a feminist countertradition of showing the land's unruly parts: its dry scrub, burnt ends, and components that threaten constantly to absorb or overtake human progress. Like Judy Chicago, Agnes Denes, Beverly Buchanan, and other feminist image makers who use land as their material and their thematic focus, Fritz occasionally casts trees and agriculture as new kinds

of invaders. But in showing the Nebraska National Forest's resilient production cycles as well, Fritz's pictures reveal the ability of supplemental plantings to weave themselves fully into their surroundings. They digest otherness; they create botanical hybridity.

More importantly, the images in this book provide a starting point to for us to note our own fantasies about land that we bring to pictures. Moment by moment we draw on narratives that are precious to us and apply them to organisms living and nonliving. Bonney Hartley, the tribal historic preservation manager of the Stockbridge-Munsee Band of Mohican Indians, has proposed that every view of a given natural space is a "beloved view."[14] When Fritz's view invites us to become curious about sand, grass, or broken trunks of trees, we experience the way a beloved view comes into being. Instead of absorbing the constructed landscapes without criticism, we take part in supplementary thinking, examining the small differences in beings and spaces, stitching together new possibilities from the constructed landscapes that are the legacy of western expansionist thought.

NOTES

1. John P. Husmann suggests that the metaphor and figure of the garden had multiple meanings with turn-of-the-century land reclamation projects in the United States. For more, see Husmann, "'A Rare Garden Spot': A History of the Nebraska National Forest," master's thesis, University of Nebraska–Lincoln, 1998.

2. Julius Sterling Morton, speech at the opening of the University of Nebraska in 1871. Quoted in Donald R. Hickey, Susan A. Wunder, and John R. Wunder, *Nebraska Moments* (Lincoln: University of Nebraska Press, 2007), 124.

3. Nebraska State Legislature, "Summarized History of the Nebraska State Weed Law," quoted in Frieda Knobloch, *The Culture of Wilderness: Agriculture as Colonization in the American West* (Chapel Hill: University of North Carolina Press, 1996), 135.

4. William Darlington, *American Weeds and Useful Plants: Being a Second and Illustrated Edition of Agricultural Botany* (New York: A. O. Moore, 1850), xiii.

5. Lisa Knopp, *The Nature of Home: A Lexicon of Essays* (Lincoln: University of Nebraska Press, 2002), 33–34.

6. John J. Buchkoski, "'Being Judged by Its Fruits': Transforming Indian Land into Orchards along the Arkansas River, 1800–1867," *Great Plains Quarterly* 39, no. 1 (Winter 2019): 40.

7. From Morton's editorial contribution to *Nebraska City News*, March 12, 1870, quoted in Knopp, *The Nature of Home*, 35.

8. Kim TallBear, "Beyond the Life/Not-Life Binary: A Feminist-Indigenous Reading of Cryopreservation, Interspecies Thinking, and the New Materialisms," in Joanna Radin and Emma Kowal, *Cryopolitics: Melting Life in a Frozen World* (Cambridge MA: MIT Press, 2017), 180.

9. U.S. Forest Service, "A New Look at the Objectives for the Sandhills Zone of the Nebraska National Forest Following the Plum Creek Fire—1965."

10. Jacques Derrida, *Of Grammatology*, trans. Gayatri Chakravorty Spivak (Baltimore: Johns Hopkins University Press, 1976), 167, 144–45.

11. Ansel Adams, *The Camera: The Ansel Adams Photography Series, Part 1* (New York: Knopf, 1997), 119.

12. Judy Chicago, *Through the Flower: My Struggle was a Woman Artist*, 2nd ed. (iUniverse, 2006), 57.

13. In China, for instance, the annual Arbor Day, inaugurated in 1916, consisted of ceremonial planting of trees. See Larissa Pitts, "Unity in the Trees: Arbor Day and Republican China, 1915–1927," *Journal of Modern Chinese* 13, no. 2 (2019): 296–318.

14. Bonney Hartley (Stockbridge-Munsee Mohican), quoted in *Native Perspectives* (New York: Metropolitan Museum of Art, 2021); accessed August 13, 2021, https://www.metmuseum.org/about-the-met/collection-areas/the-american-wing/native-perspectives.

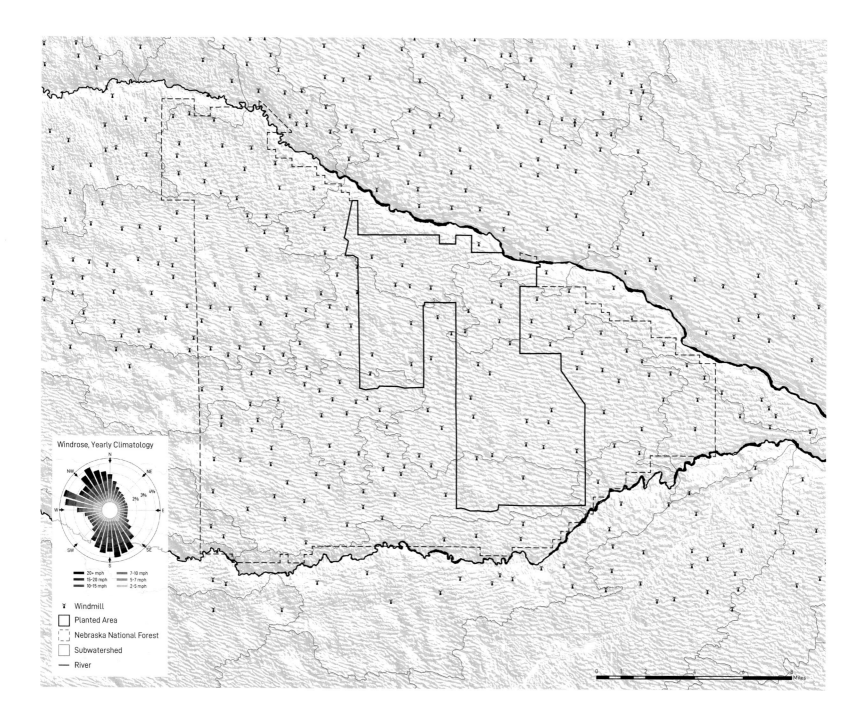

Windrose, Yearly Climatology

NW N NE

W E
 2% 3% 4%

SW S SE

20+ mph 7-10 mph
15-20 mph 5-7 mph
10-15 mph 2-5 mph

⊼ Windmill

☐ Planted Area

▢ Nebraska National Forest

☐ Subwatershed

— River

0 1 2 4 6 8
 Miles

sand / wind / water

Sand, wind, and water shape the Bessey Ranger District, part of the unique ecosystem of the Nebraska Sandhills, the largest stabilized dune field and largest area of undisturbed grassland in the Western Hemisphere. This semi-arid landscape absorbs rainfall and local snowmelt directly into the earth. The mixed-grass prairie flora stabilize the formerly shifting dunes that cover the massive High Plains Aquifer feeding the rivers with springs. Bounded by the Middle Loup River on the north and the Dismal River on the south, the Bessey Ranger District includes native grasses and shrubs, planted forest, and some bare areas. One such area is an exposed dune on the north bank of the Dismal, where the sands shift in the constant wind, burying barbed-wire fences and defying most vegetation. This area, adjacent to a campground inadvisably accessed by passenger car, attracts visitors with four-wheel drive and off-road vehicles. Their tracks are perpetually erased by the strong winds. Wave patterns occur at various scales, from the large dunes to the sandy riverbeds.

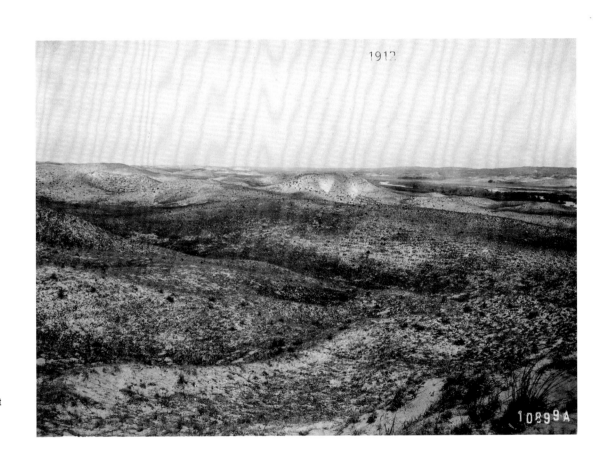

1912

10899A

P13. C. G. Bates. *View from Sec. 6 T. 22, R. 27W. Hills along point facing Loup River, showing effect of overgrazing due to lack of water farther back.* Photo courtesy U.S. Forest Service Archives.

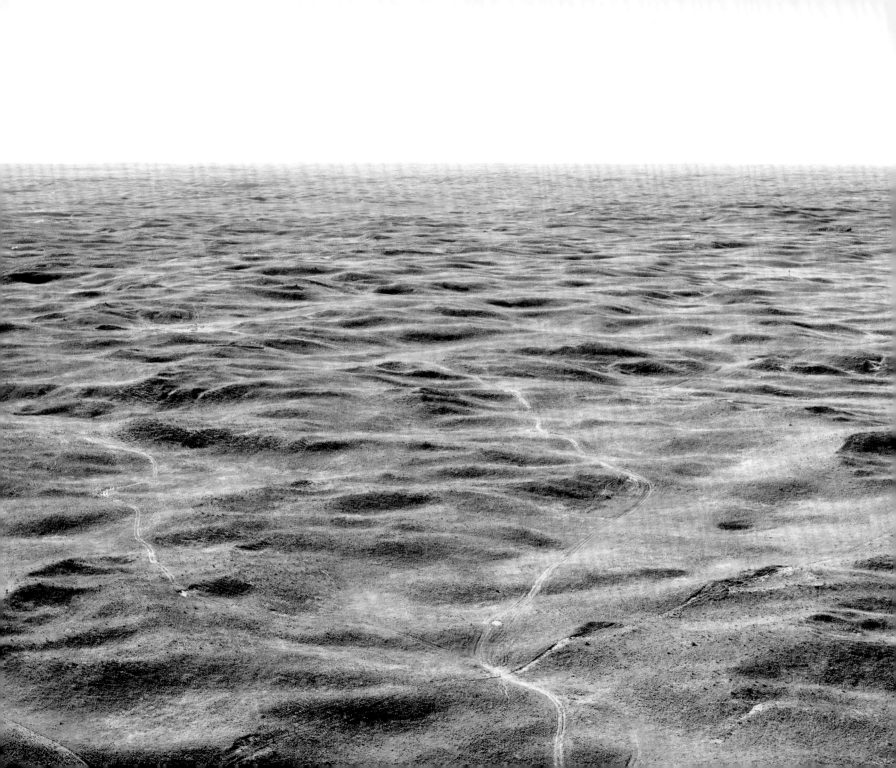

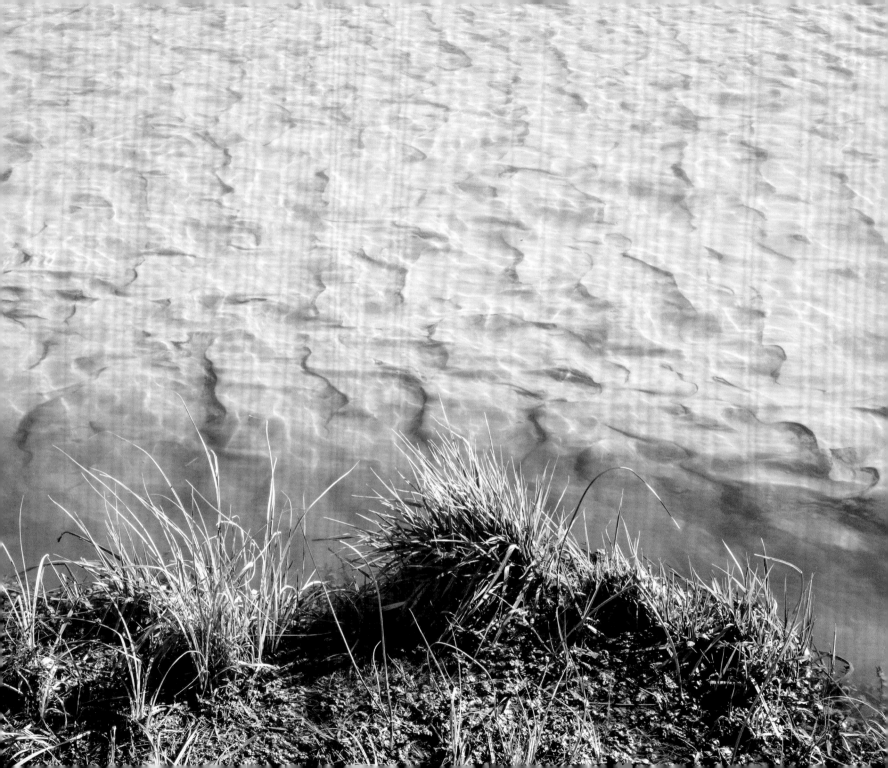

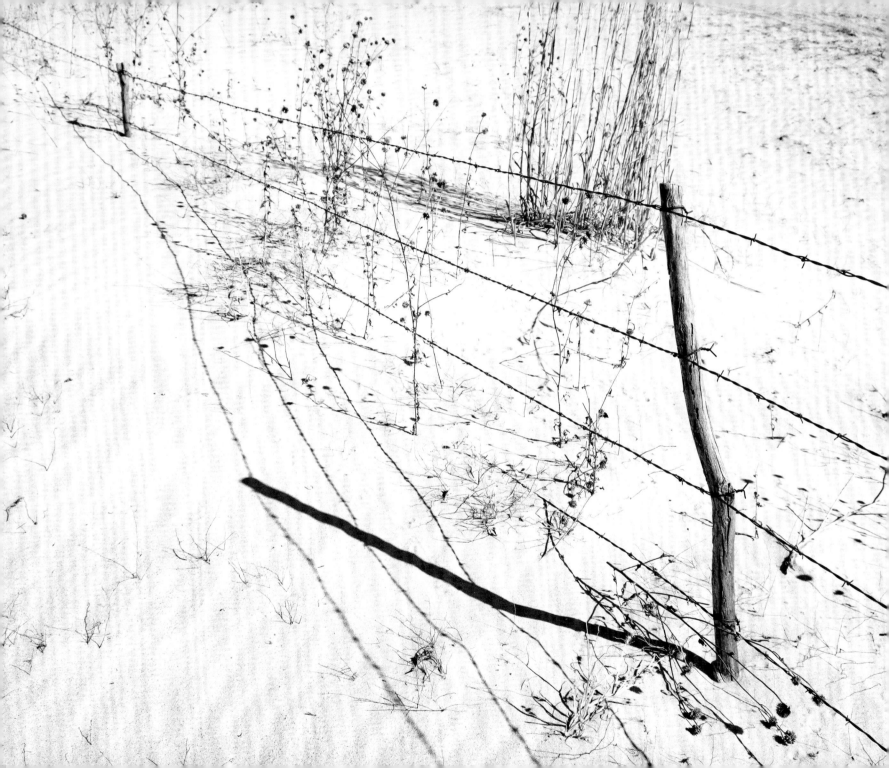

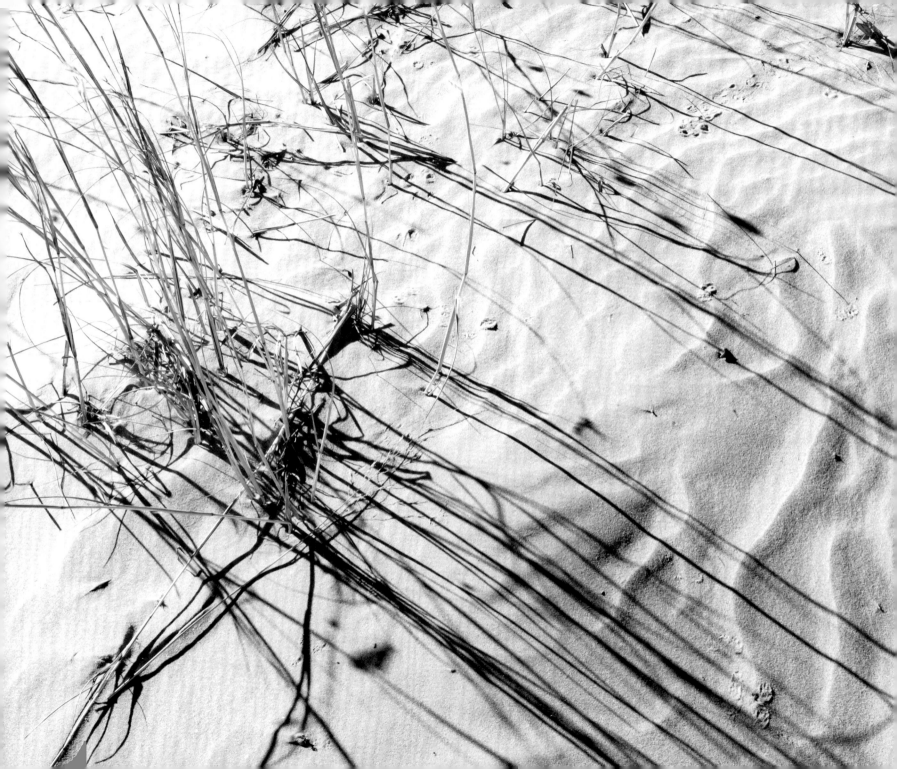

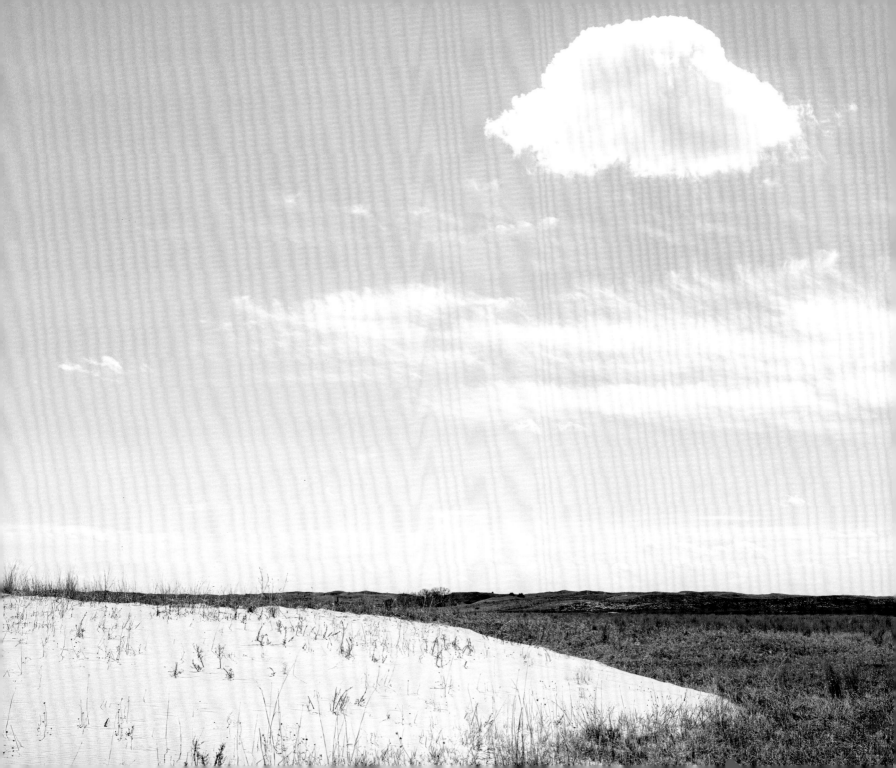

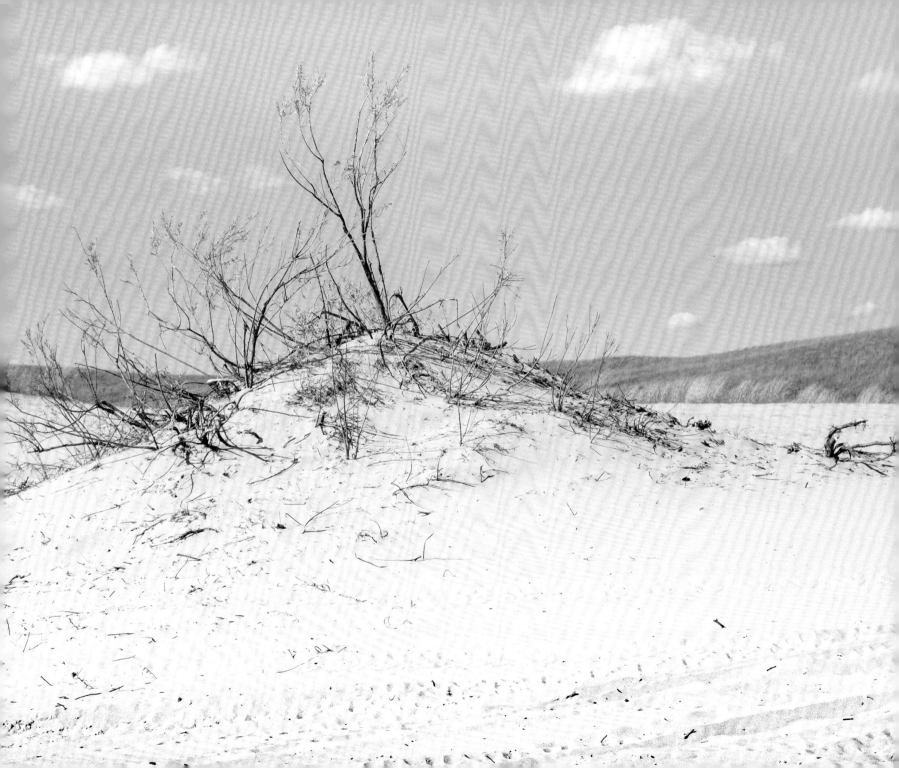

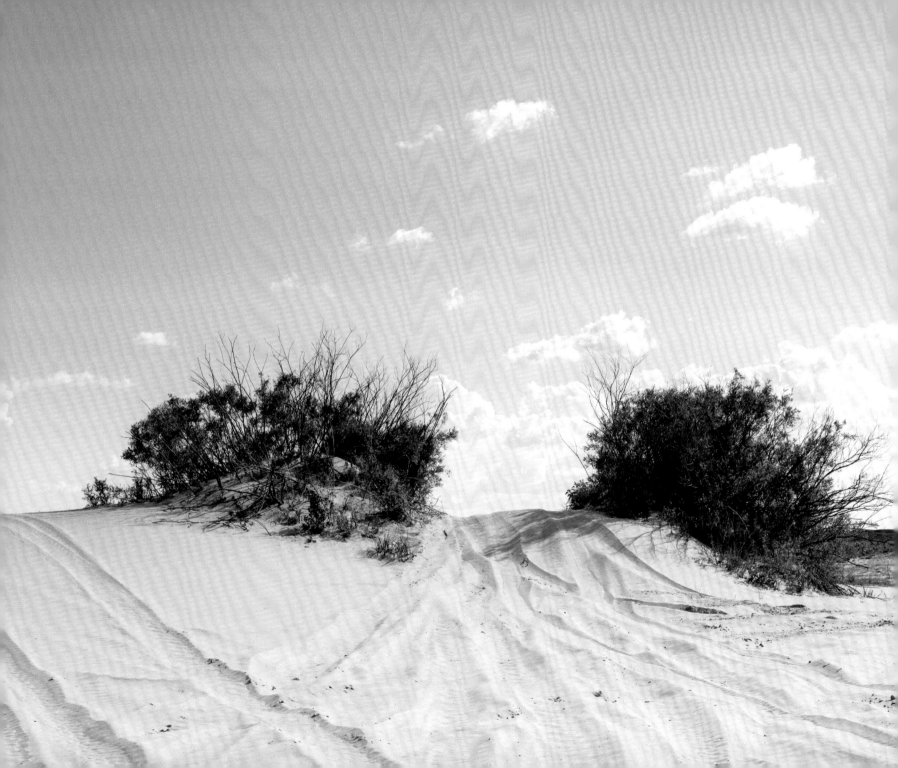

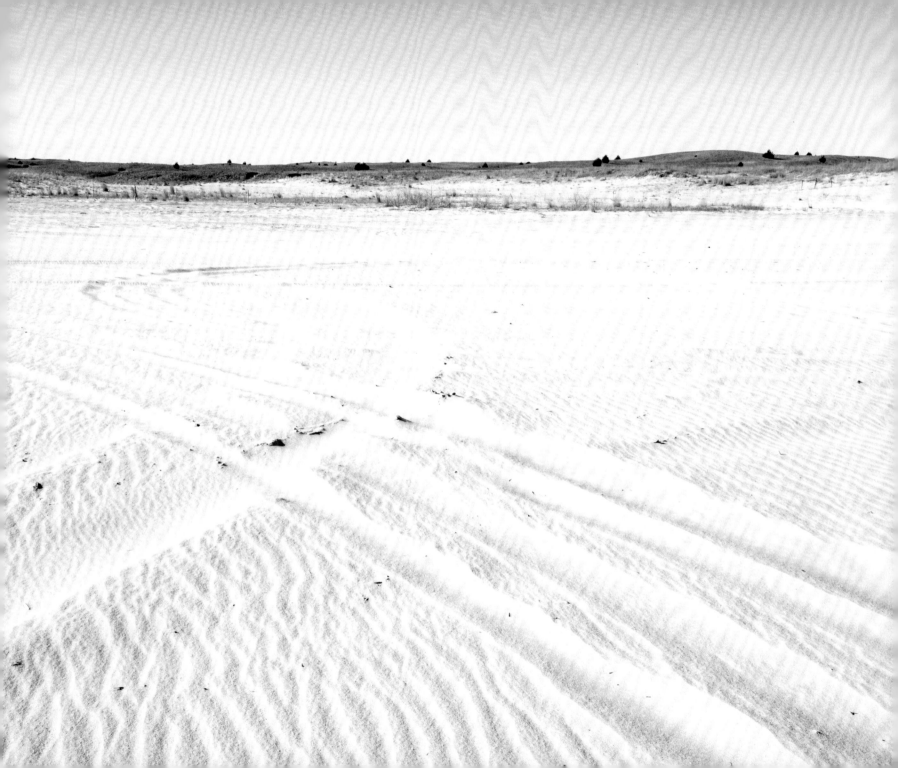

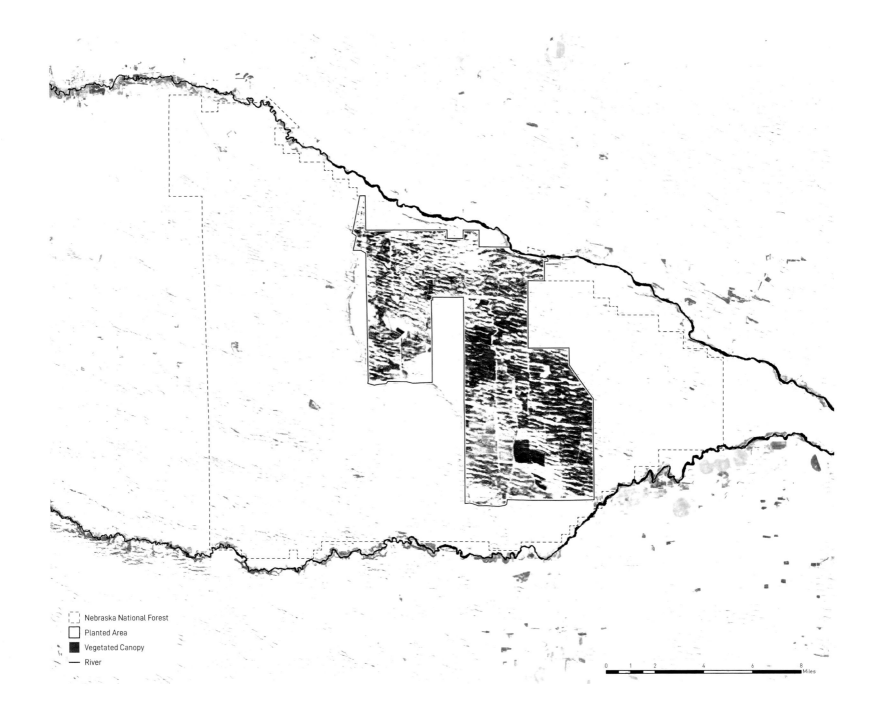

Nebraska National Forest

Planted Area

Vegetated Canopy

River

0 1 2 4 6 8
 Miles

planting

In 1902, Charles Bessey convinced President Theodore Roosevelt to set aside a nearly treeless expanse of Nebraska Sandhills as a forest reserve. It was not a hard sell: the settler mindset views the grasslands as disorderly and unproductive, and trees as corrective. The first planting occurred in spring 1903 and afforestation continued until the mid-twentieth century, first with horse-drawn implements and, by 1929, with tractor-pulled plows and trenchers. The land was generally deemed unsuitable for crops, yet seedlings were planted in furrows at regular intervals between wide unplanted areas to stop wildfires. Several tree species were planted experimentally in the early years until ponderosa pine, jack pine, and eastern redcedar proved to be best suited to the area. The regularity of planted rows has dissolved over time through high seedling failure rates, natural death, pests, drought, and fire. Administered by the U.S. Department of Agriculture, national forests were conceived as sites of mixed-use sustainable resource management that included timber production. Bessey likened the forest to an orchard that would be harvested but not destroyed. He was alarmed by the mass deforestation already occurring throughout the United States by the turn of the twentieth century and wrote that new forest reserves were necessary for both ecological reasons and for scientists to learn more about how to manage forests before they all disappeared.

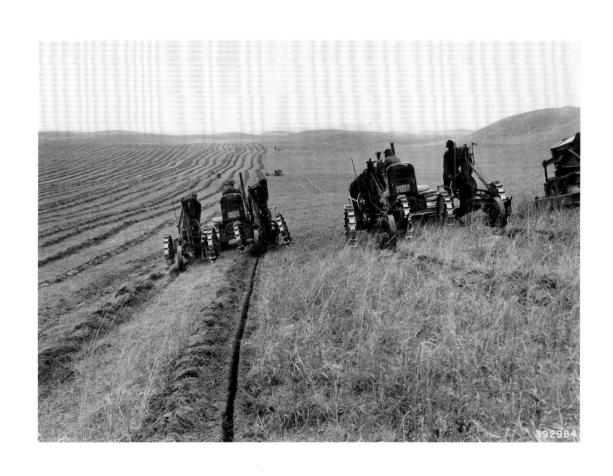

P22. *Planting crew.* N.d. Photo courtesy
U.S. Forest Service Archives.

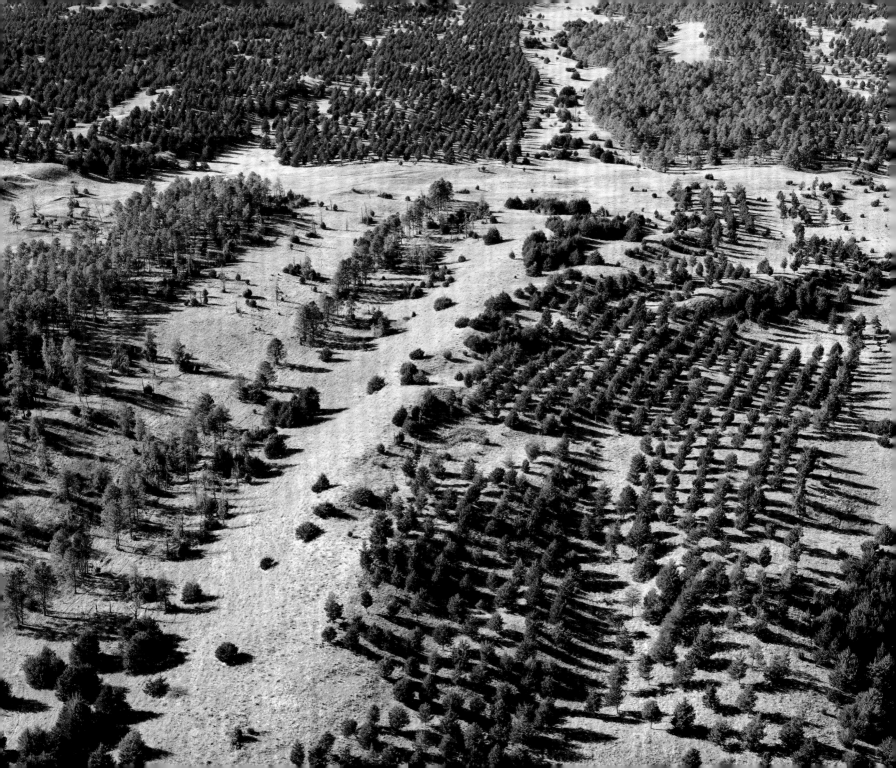

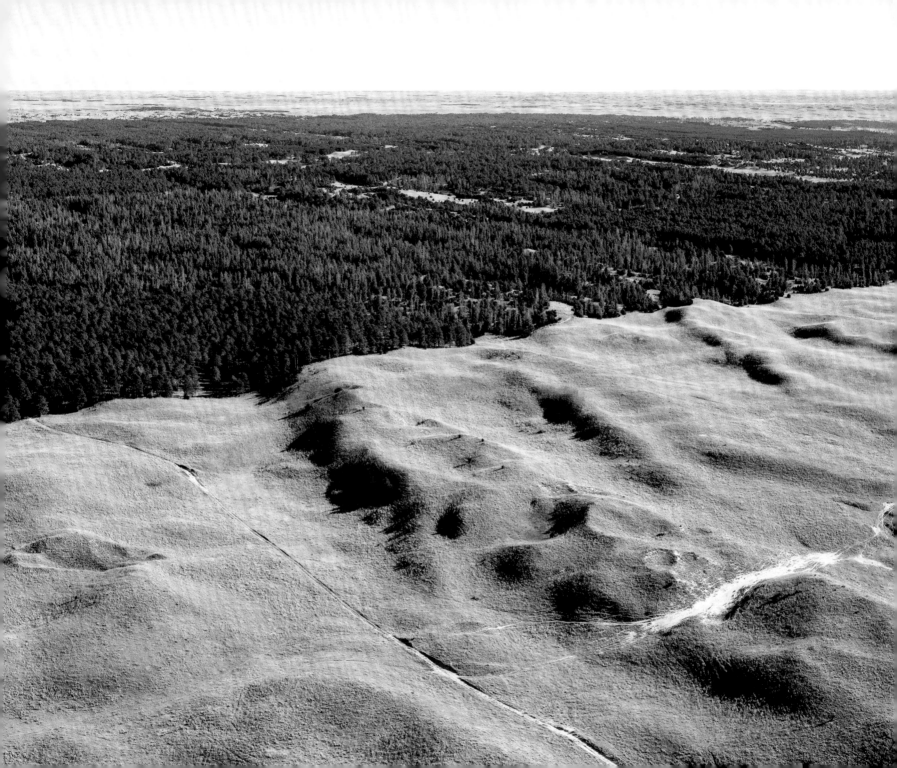

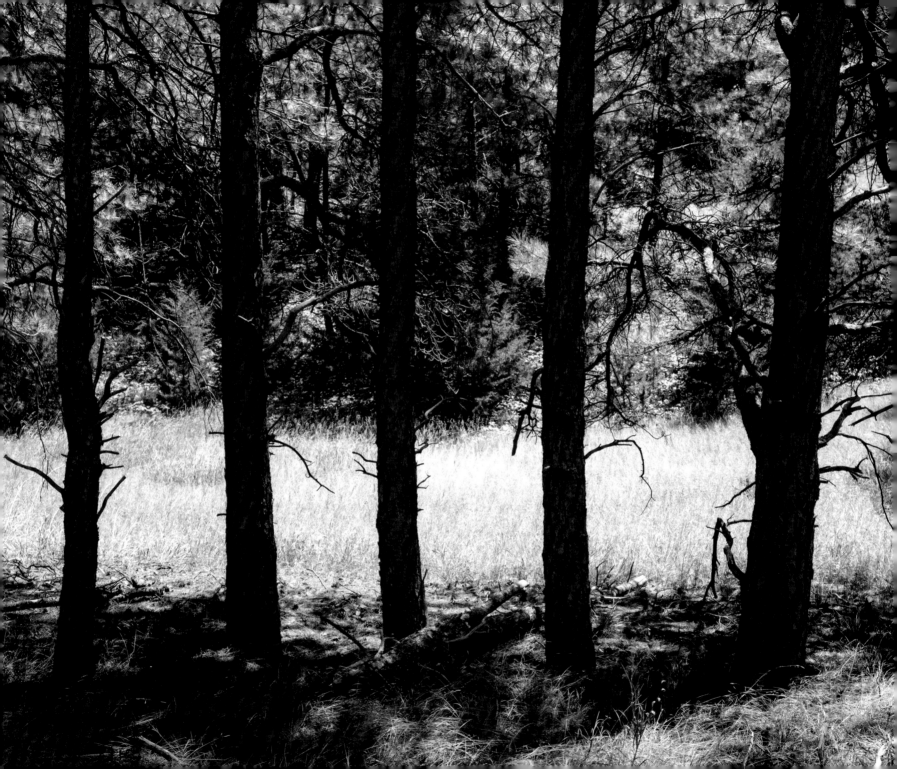

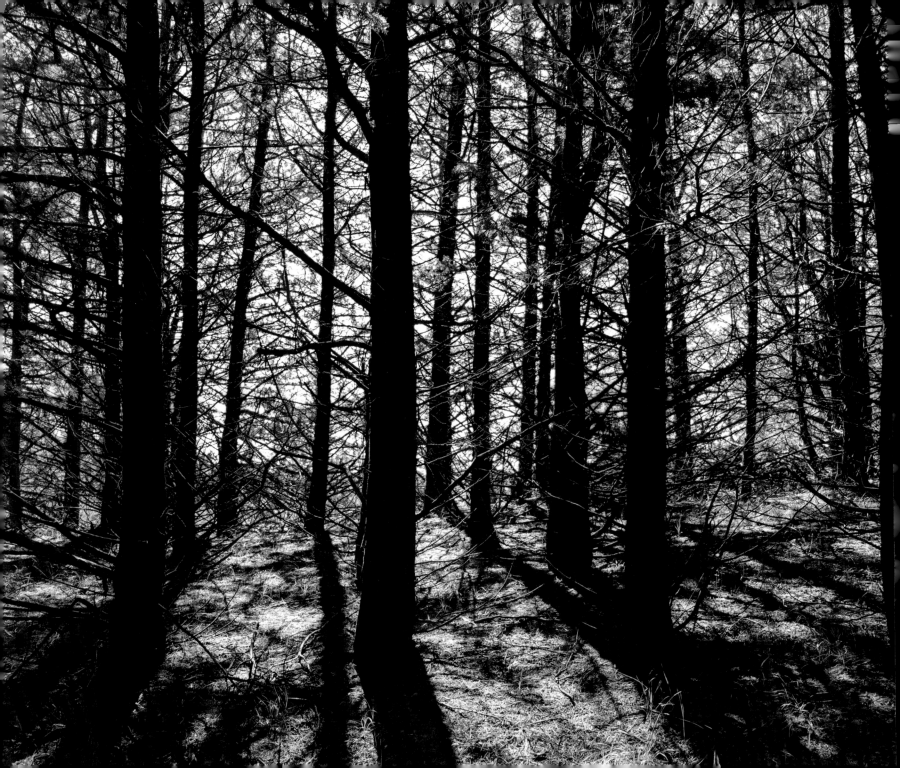

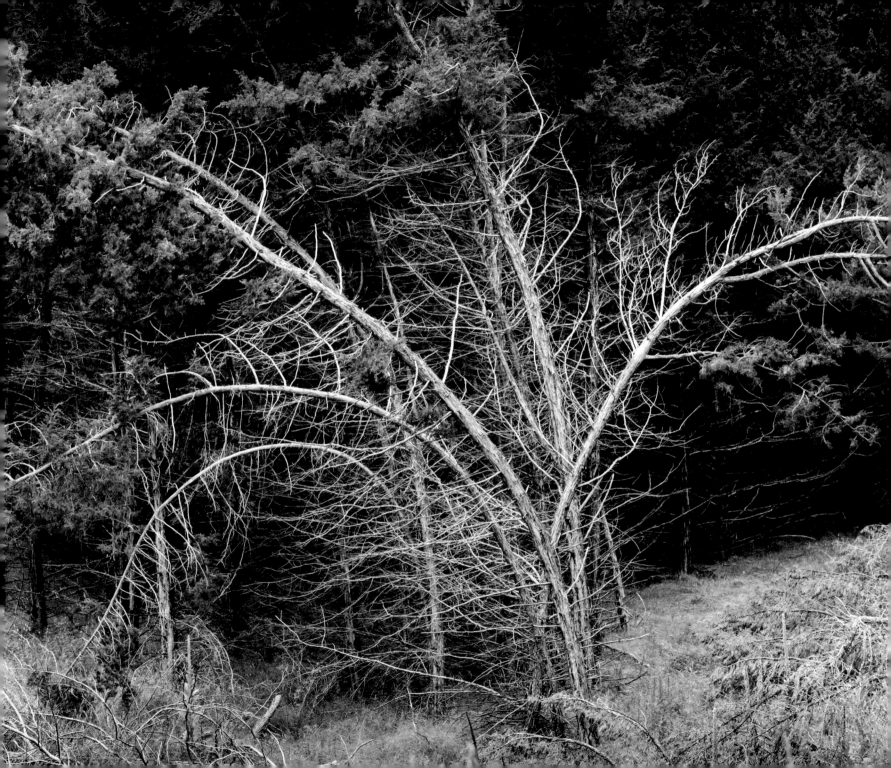

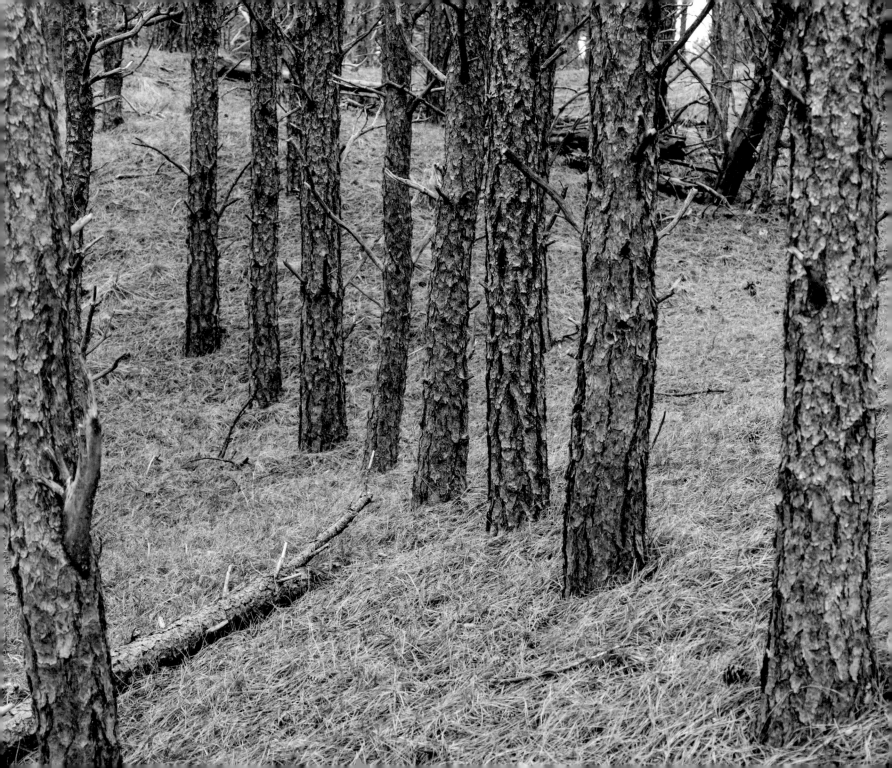

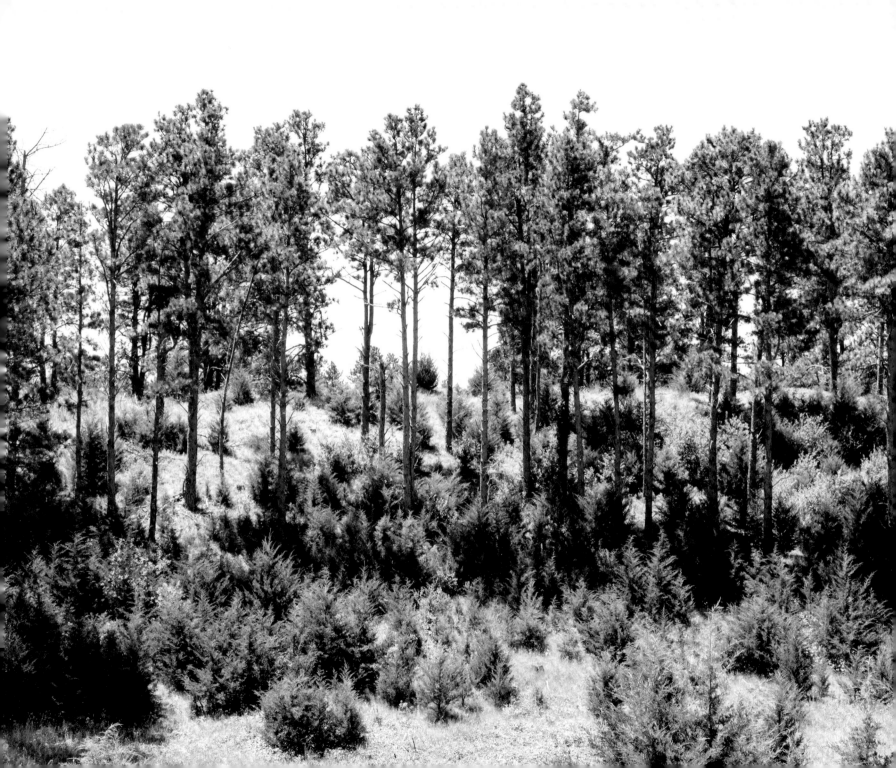

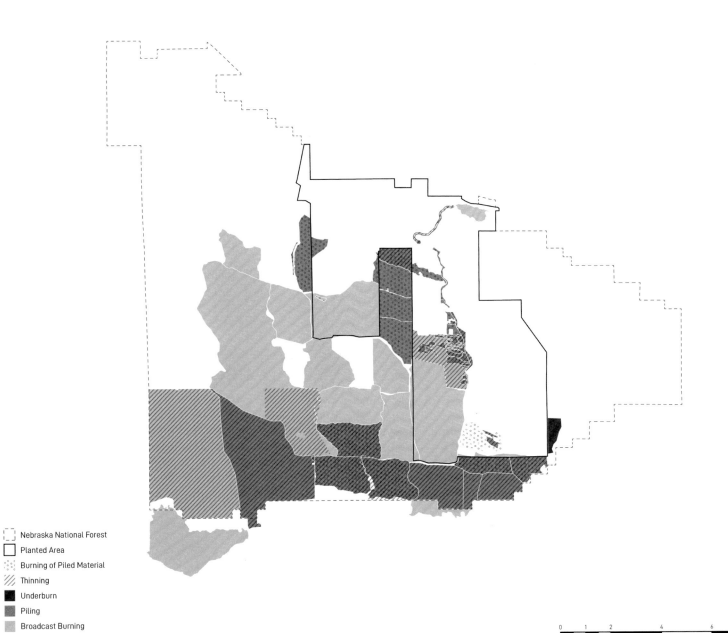

0 1 2 4 6 8
 Miles

thinning

Tree thinning as a silvicultural practice was part of early forest management in the Bessey Ranger District. Later it was used to reduce the risk of fire. This work continues in the most heavily traveled forested areas. Over time the planted eastern redcedar trees have escaped their rows and plots, causing a new kind of disorder, especially in grassland areas where fire had not been used as a management practice. An ironic inversion of labor has occurred, as effort is now directed at removing the eastern redcedars rather than planting them. To protect forested areas from destructive fires and to restore grassland integrity, the Forest Service prioritizes a particular kind of deforestation: "errant" trees are cut, moved into giant piles and ground and sold for mulch, or burned.

P31. A. L. Nelson. *Plantation # 61. Jack Pine planted 1912, thinned December 1931. Fuel wood removed, 1932.* Photo courtesy U.S. Forest Service Archives.

FOREST SERVICE
U S
DEPARTMENT OF AGRICULTURE

Subject Guide Designation.

General	Main	Sub-subject.
Timber Stand Improvement.	Thinned.	Jack pine.

OFFICIAL BUSINESS

268902

1. Locality. Bessey District.
2. Description. Plantation # 61 Jack pine planted 1912, thinned December 1931. Fuel Wood removed.
3. A. L. Nelson, photographer.
4. Date. May 18, 1932.
5. Negative No. 268902½

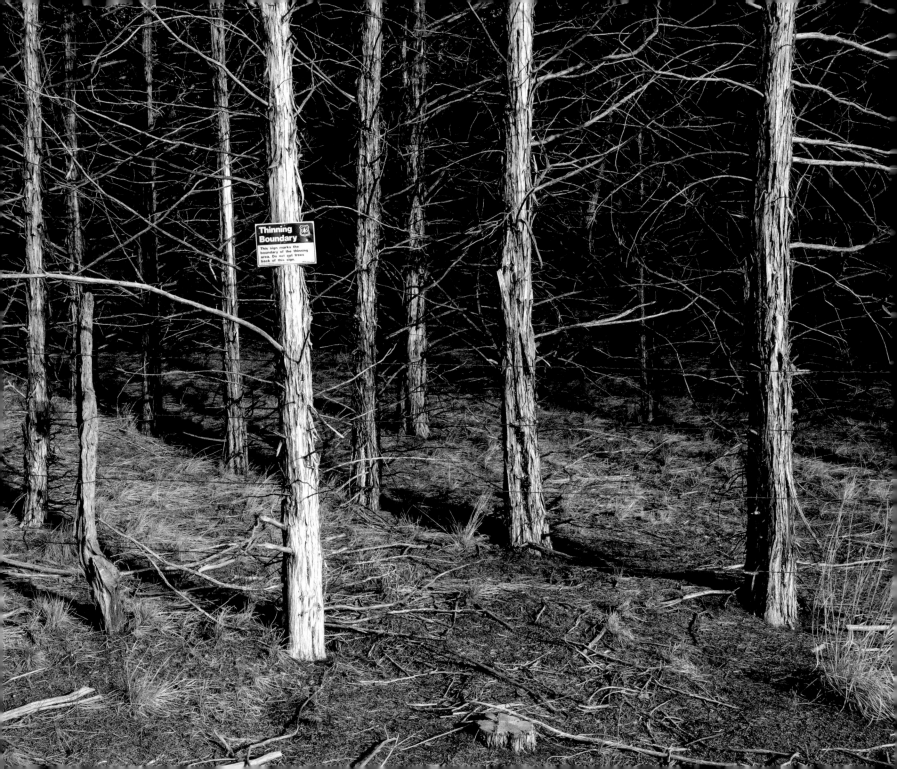

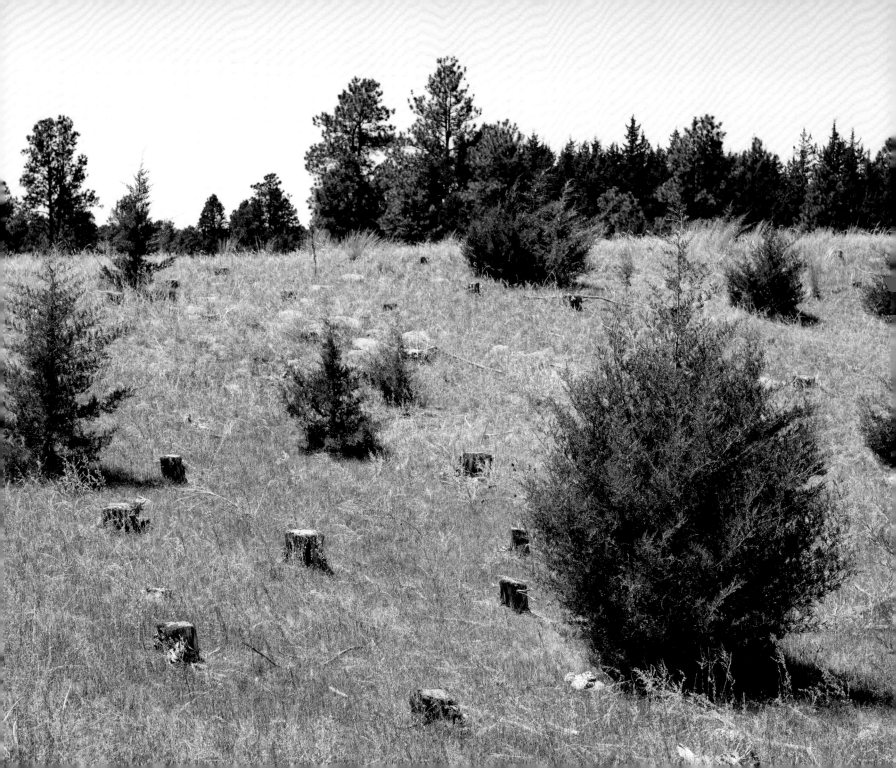

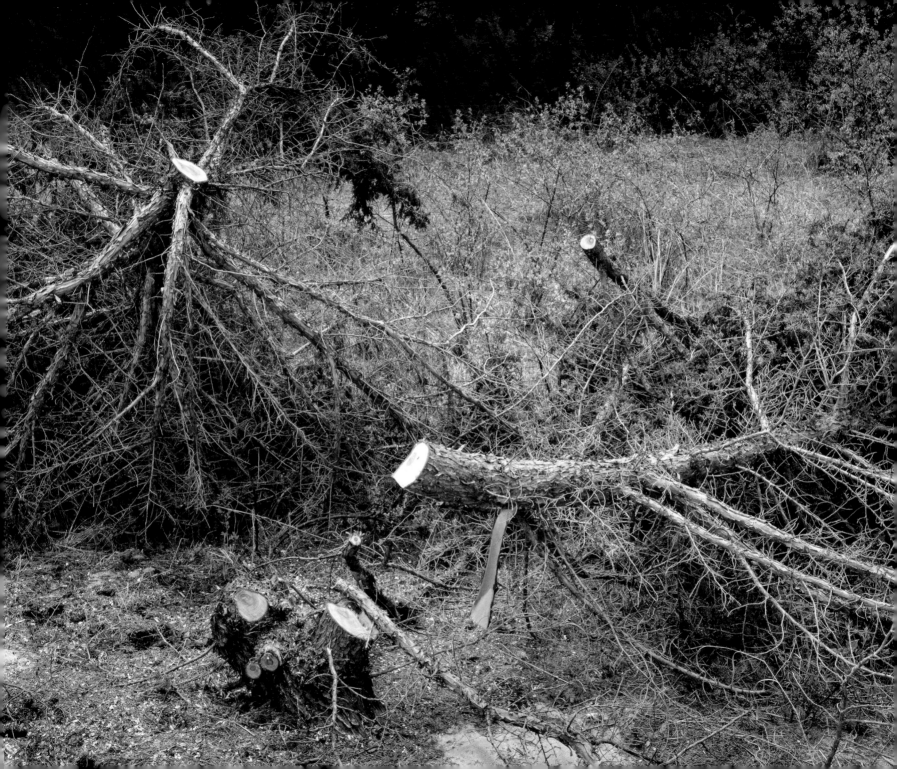

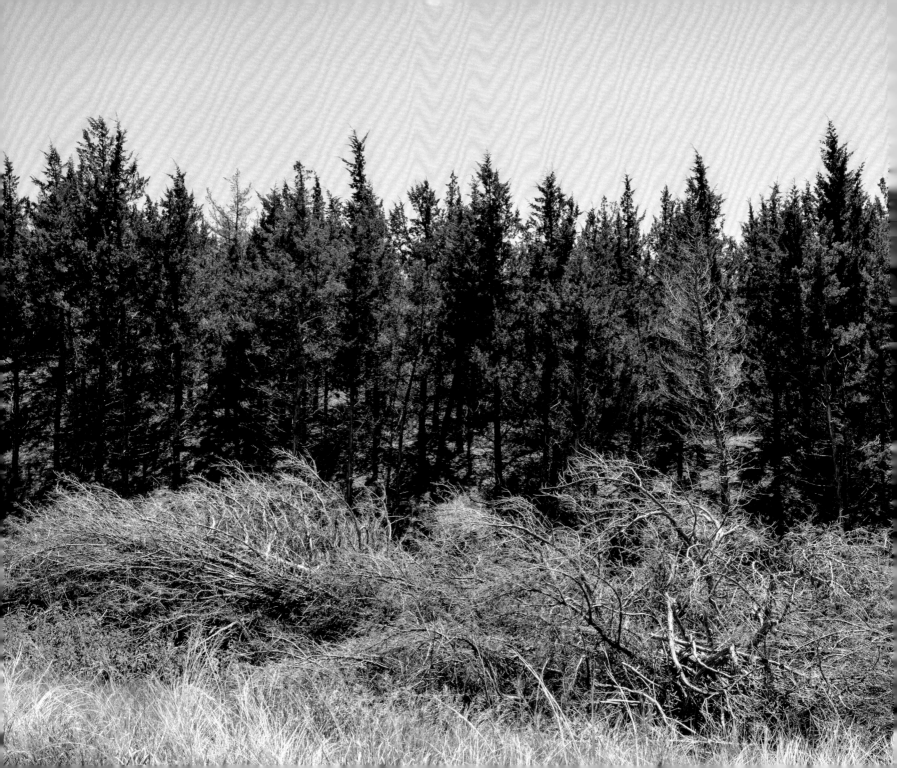

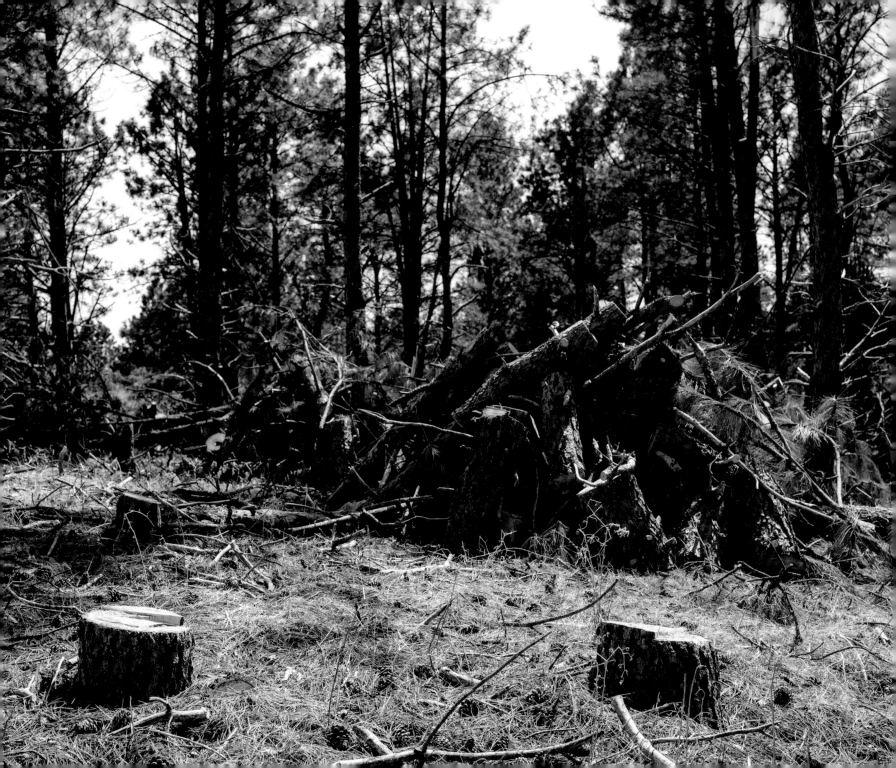

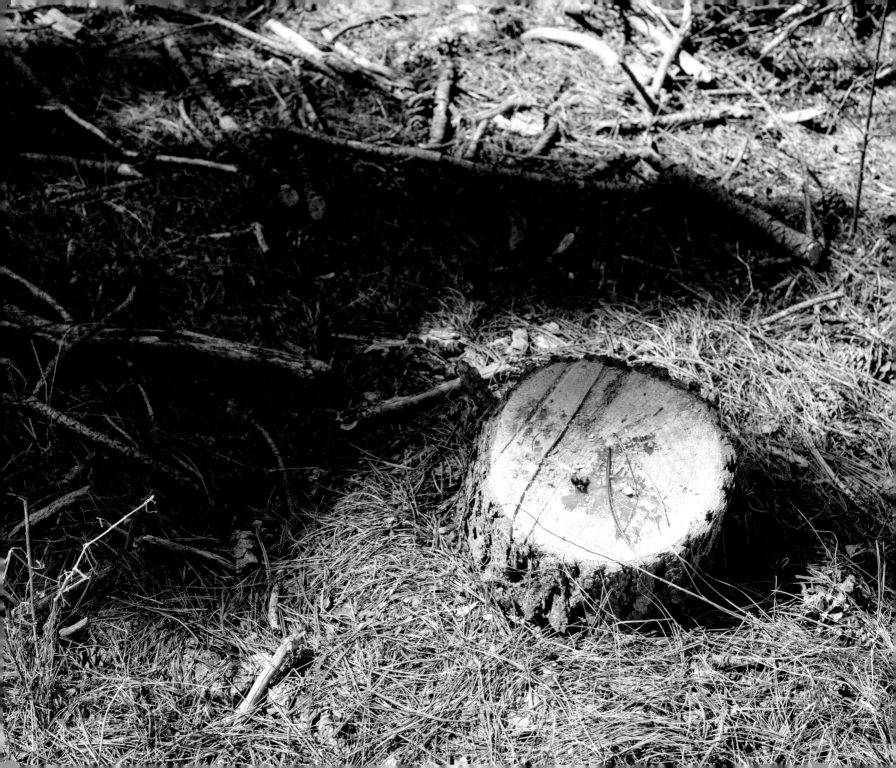

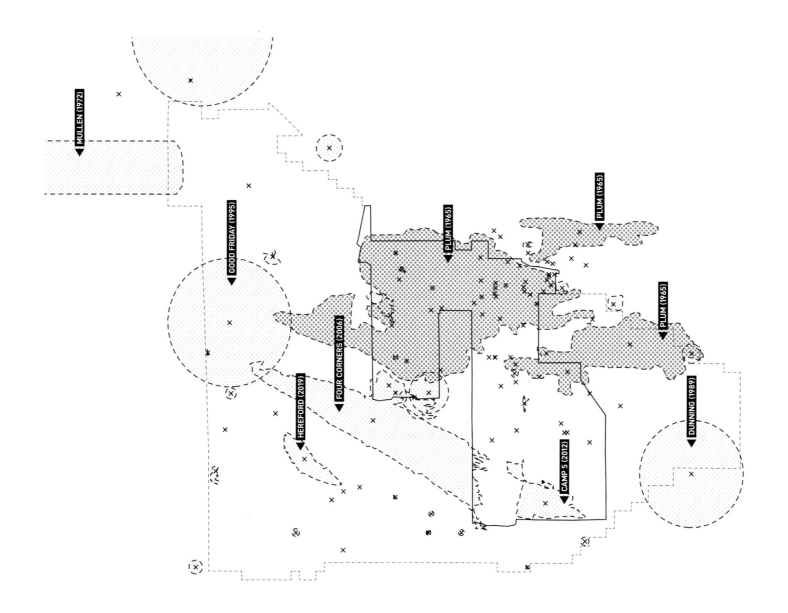

MULLEN (1972)

PLUM (1965)

GOOD FRIDAY (1995)

PLUM (1965)

PLUM (1965)

FOUR CORNERS (2006)

PLUM (1965)

HEREFORD (2019)

DUNNING (1989)

CAMP 5 (2012)

✗ Fire Occurence

 Planted Area

 Nebraska National Forest

 1965 Plum Fire

 Fire Perimeter

0 1 2 4 6 8
 Miles

fire

Fire is a natural part of forest and grassland ecosystems, and many of the species in these communities are adapted to withstand or positively react to it. Indeed, fire was used as a land management tool in grassland areas by Indigenous peoples, by some settlers, and by the Forest Service. However, massive catastrophic wildfires in the early twentieth century influenced subsequent Forest Service policy to prevent or extinguish all forest fires for most of the century. This practice left forests with an accumulation of fuel, that feeds more devastating and further uncontrollable fires that burn from the forest floor to the canopy. In recent decades the Forest Service has reintroduced controlled burning as a management strategy to reduce the damage from future wildfires. A carefully timed prescribed grassland burn in spring leaves black ash, which is soon covered by abundant green shoots that rejuvenate the entire ecosystem in just a few weeks. A low-intensity controlled burn of a ponderosa pine forest leaves black char low on the scaly trunks thick with protective bark and burns branches that have dropped but leaves the green canopy of needles. These fires clear areas for seeds to germinate

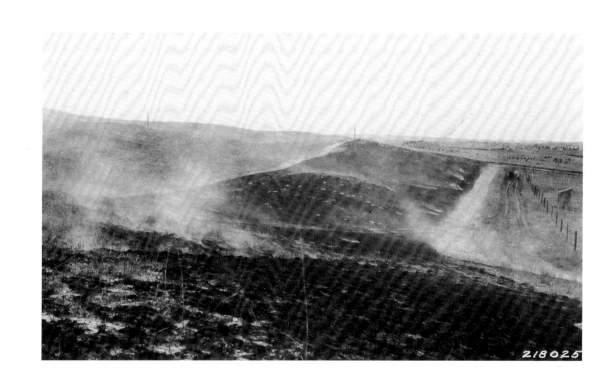

P40. F. R. Johnson. *Burning fire line around the Nebraska Planting Camp, using the planting crew for this purpose, 1927.* Photo courtesy U.S. Forest Service Archives.

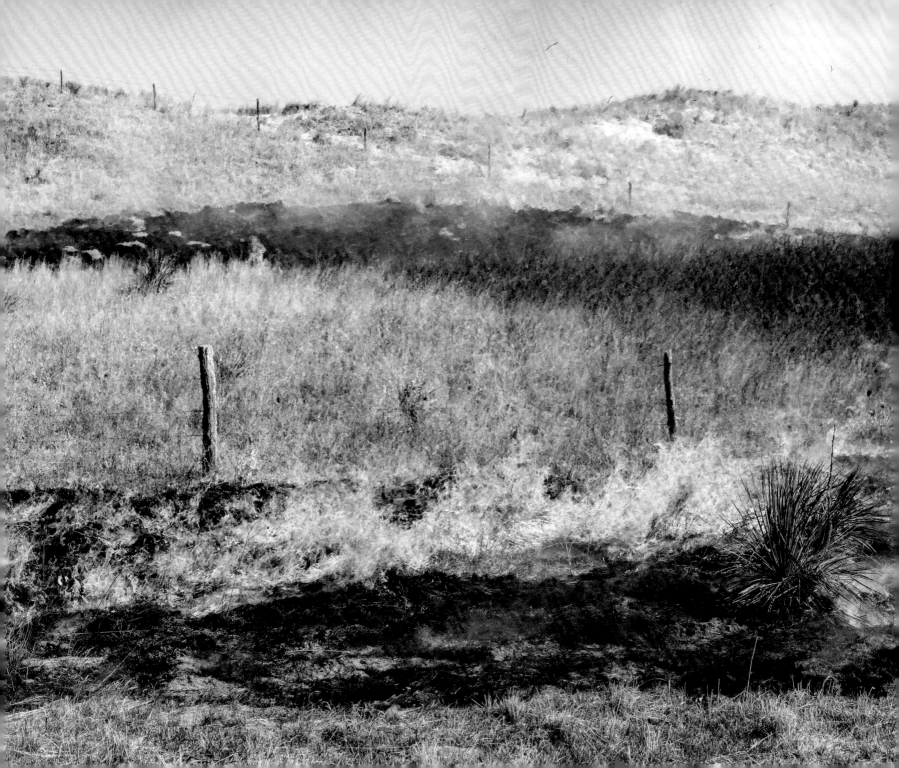

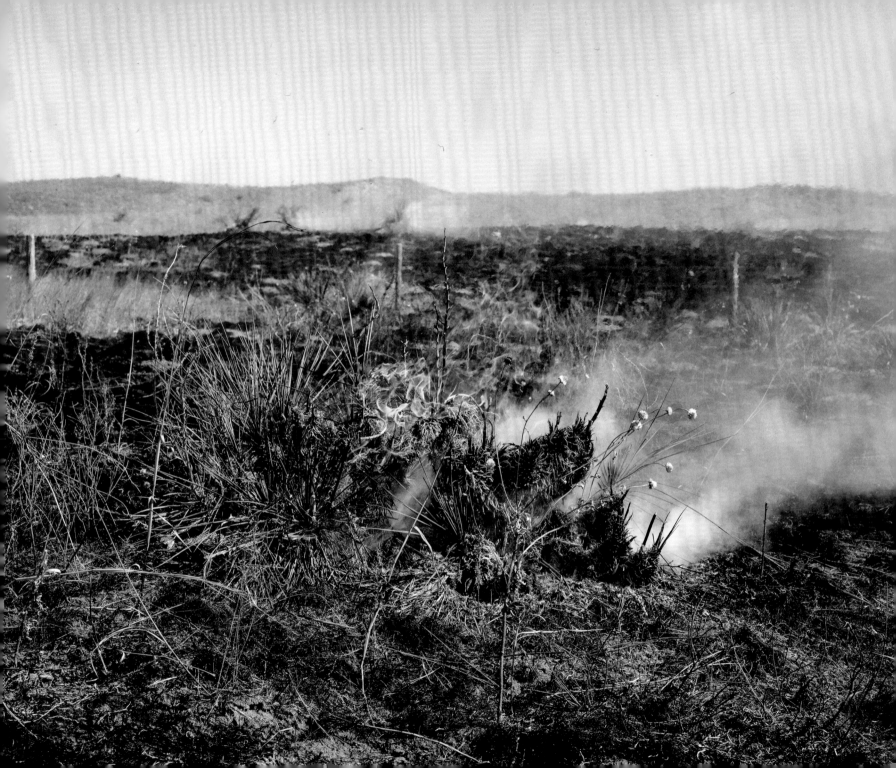

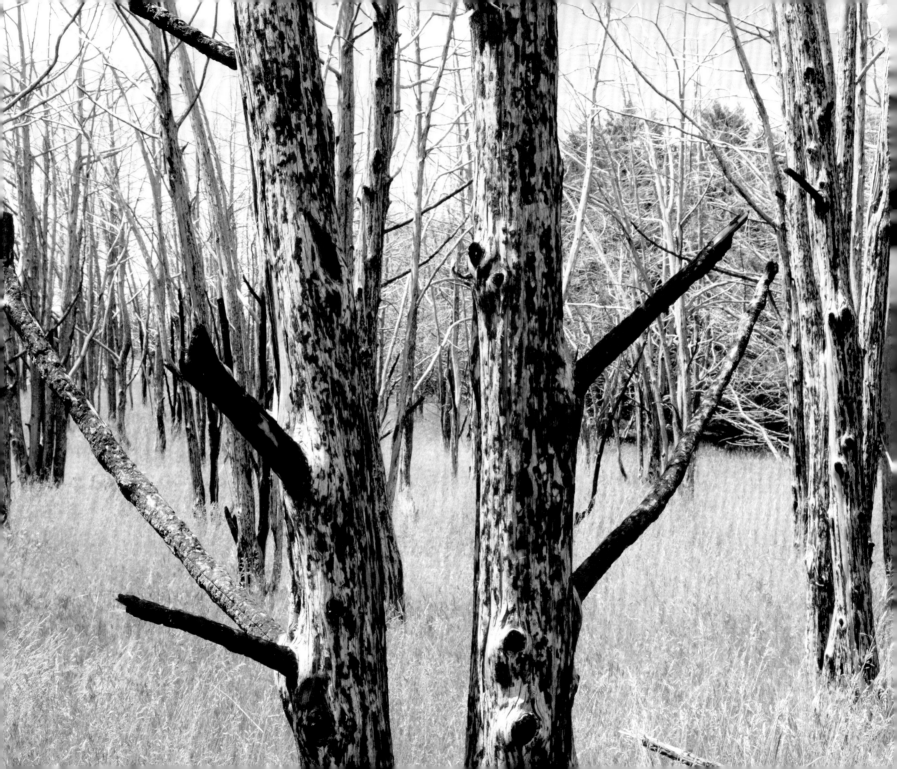

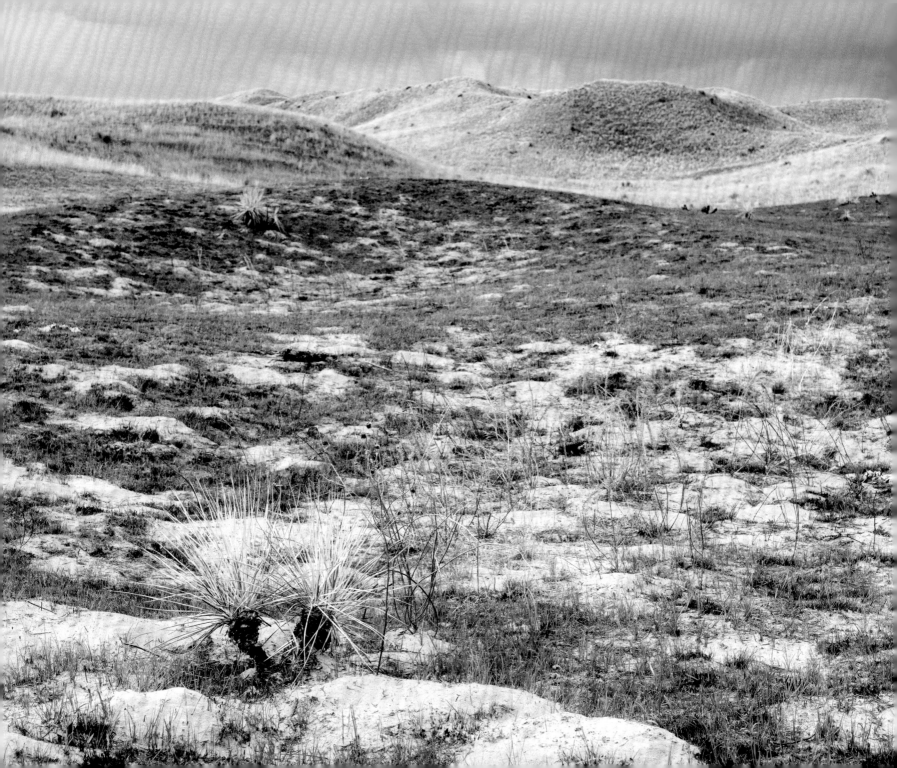

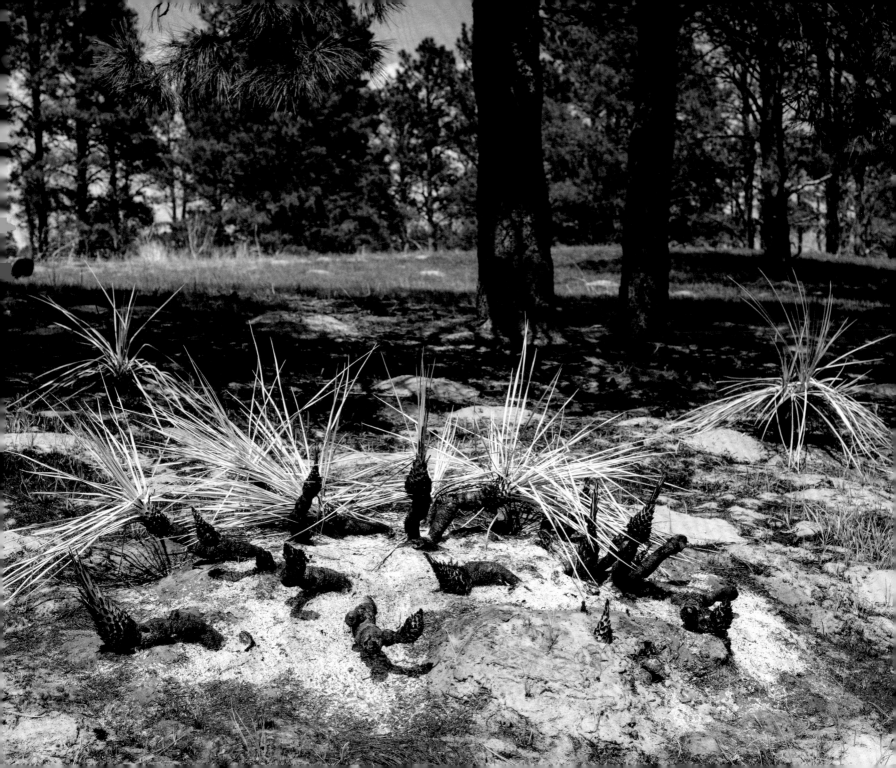

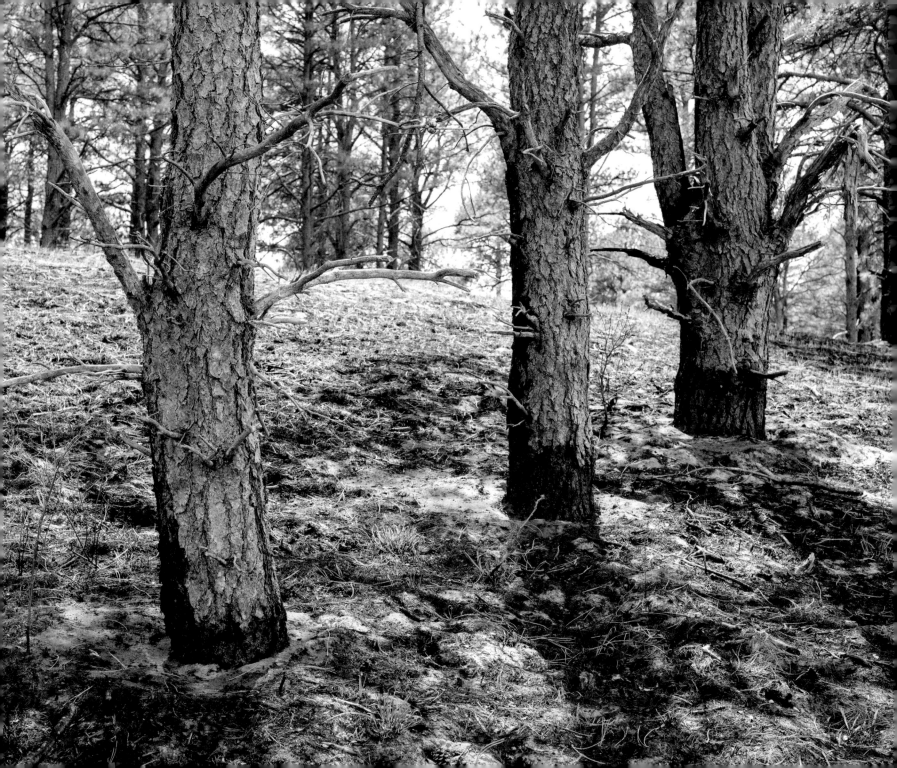

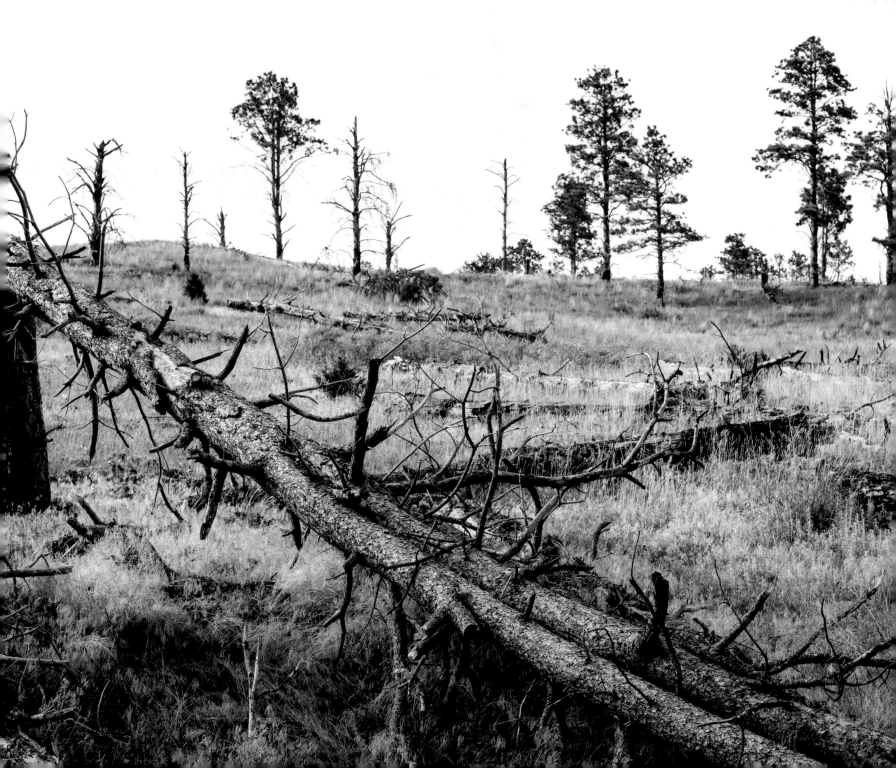

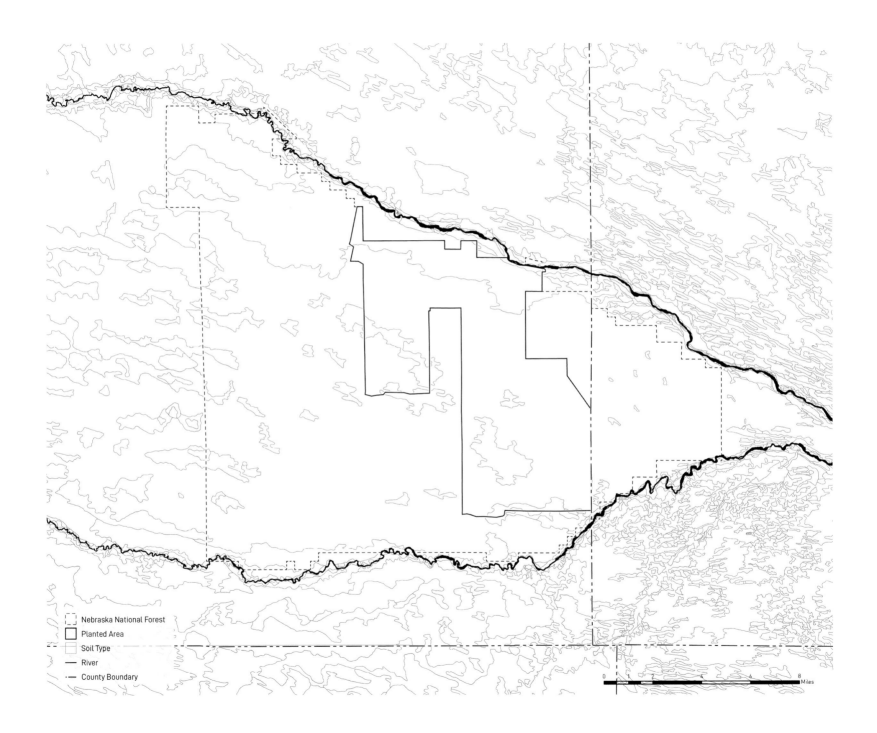

Nebraska National Forest
Planted Area
Soil Type
River
County Boundary

0 1 2 4 6 8
 Miles

decomposition

When trees die and fall due to fires, storms, diseases, pests, or old age, the regularity of the rows is further interrupted. Bark breaks free when the thin layer of living cells underneath is gone. Fungi and insects further decompose the wood, but pine needles retain their structure even while accumulating on the forest floor. New needles fall before the previous year's needles break down, sometimes burying fallen trees and branches. Deep cushions of needles prevent many species from germinating, but these horizontal forms create a new stratum of the forest, providing the habitat for animals and fungi important in nutrient cycling and protection for tenacious saplings.

P49. F. H. Shoemaker. *Depth of Litter on Top of Pure Sand. Trees Planted in 1905, 1919.* Photo courtesy U.S. Forest Service Archives.

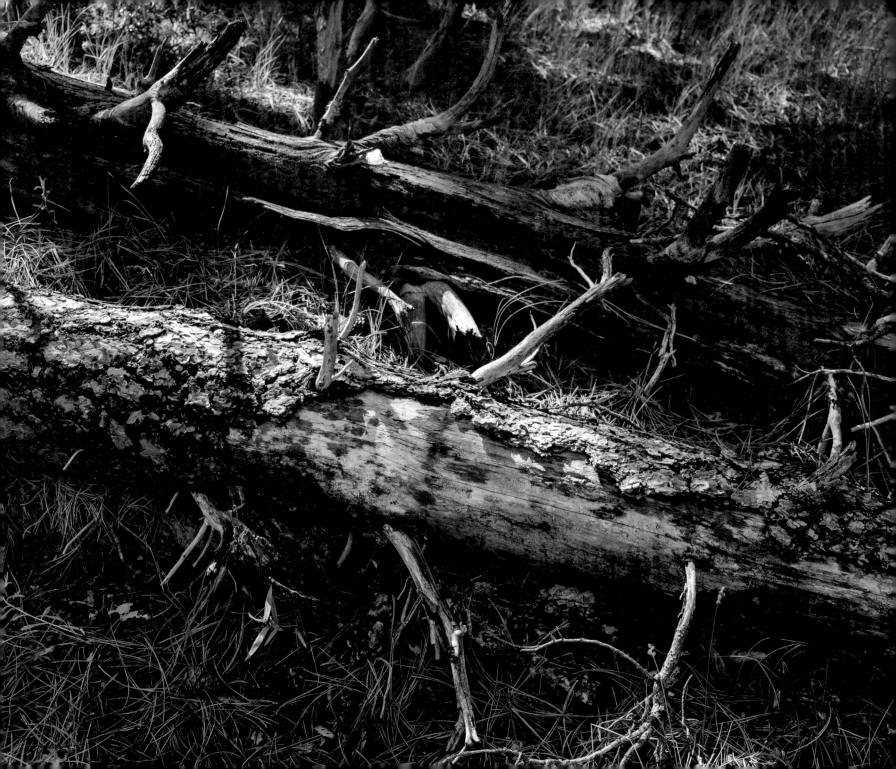

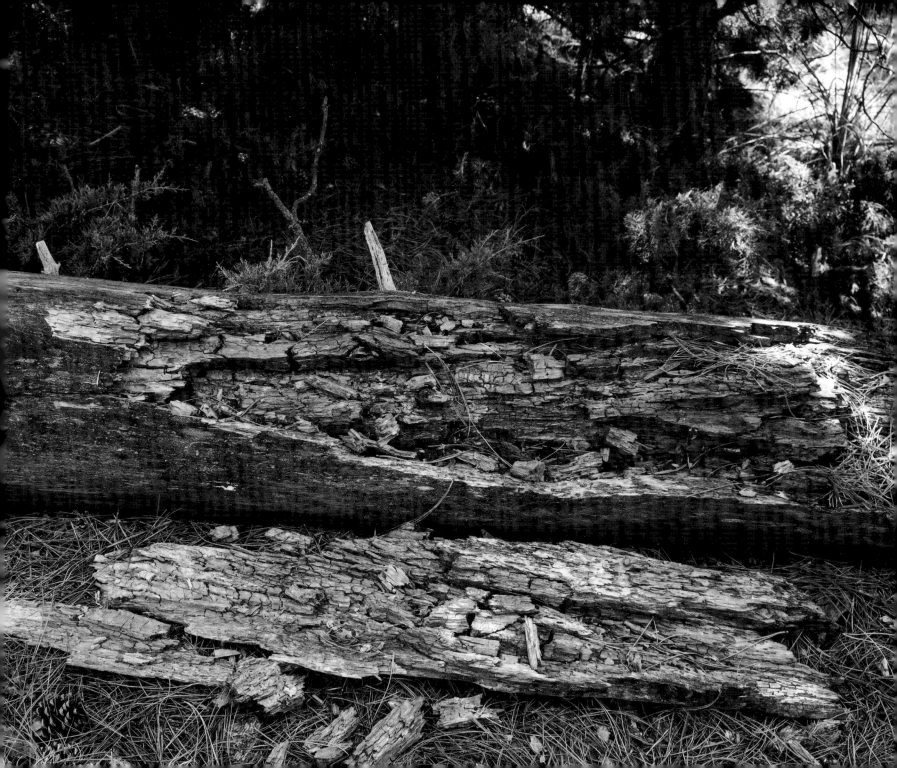

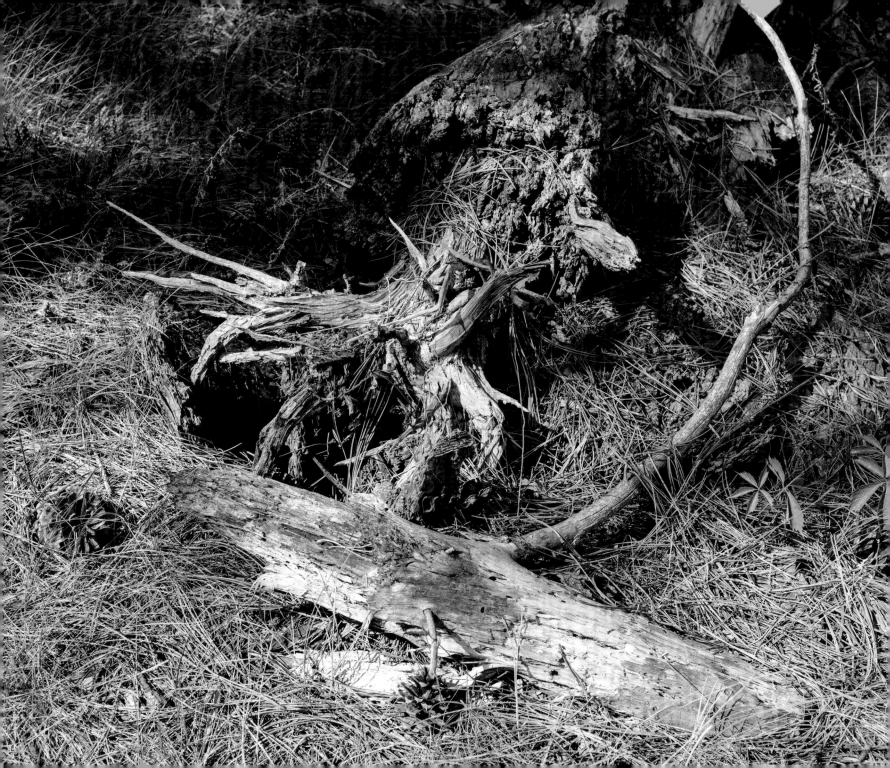

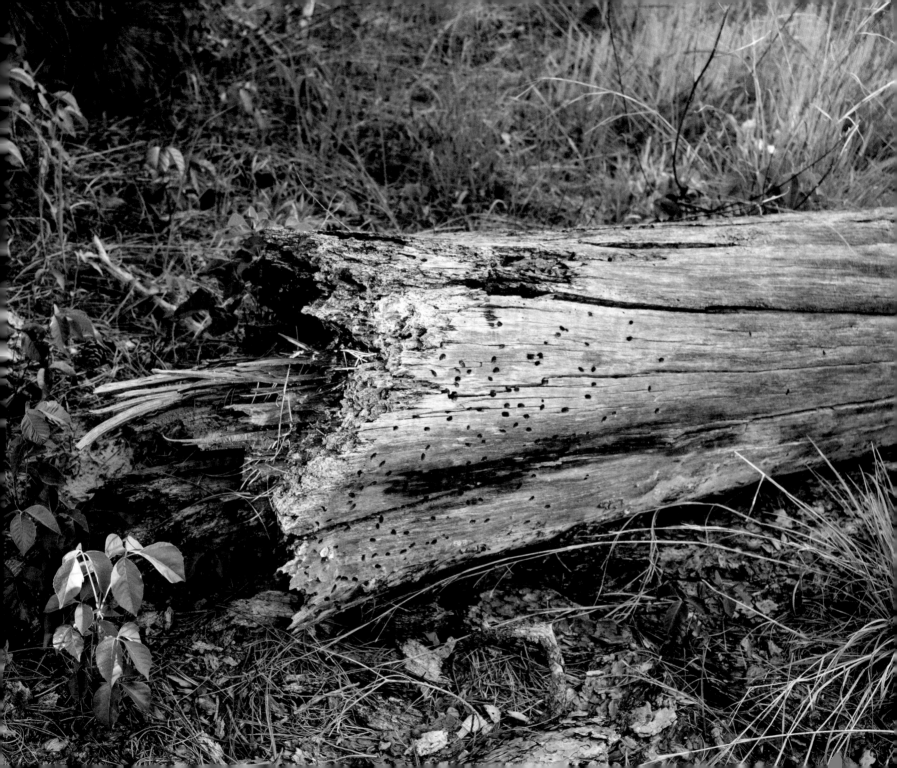

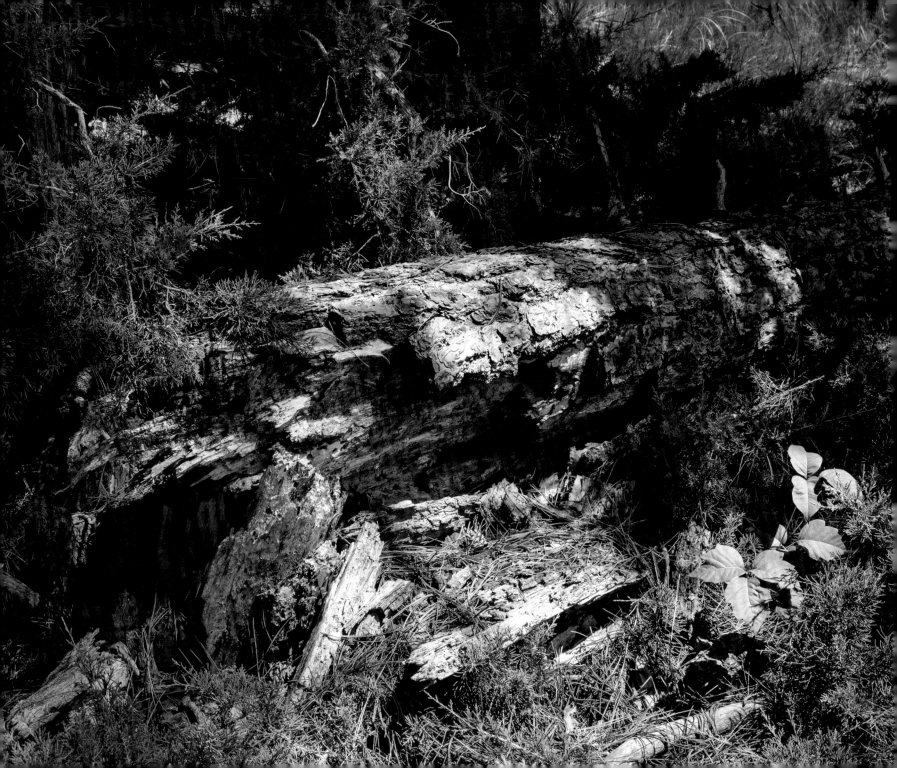

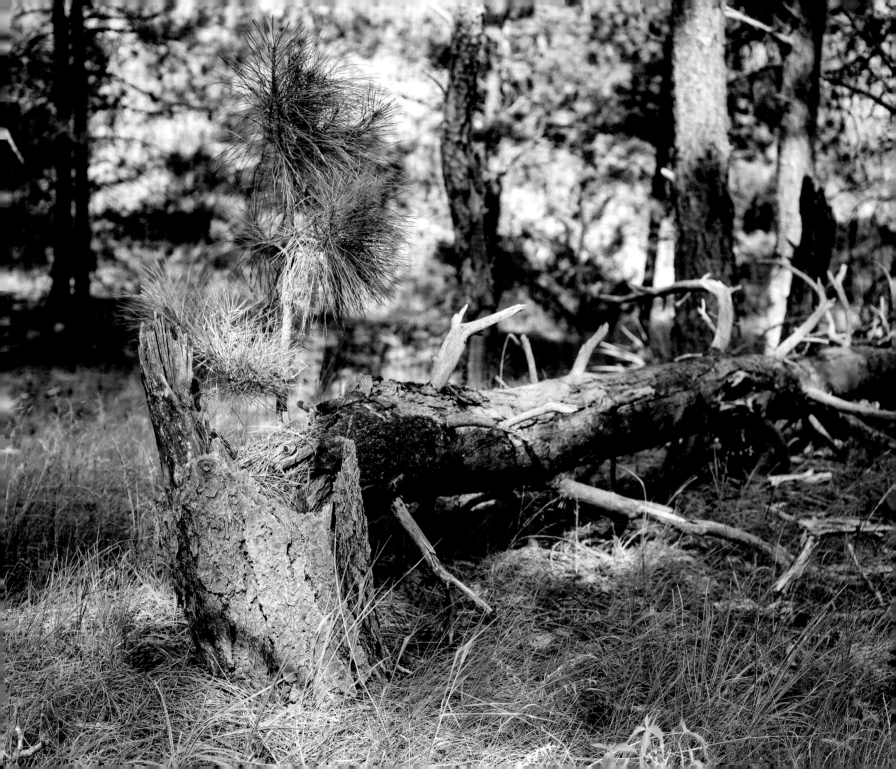

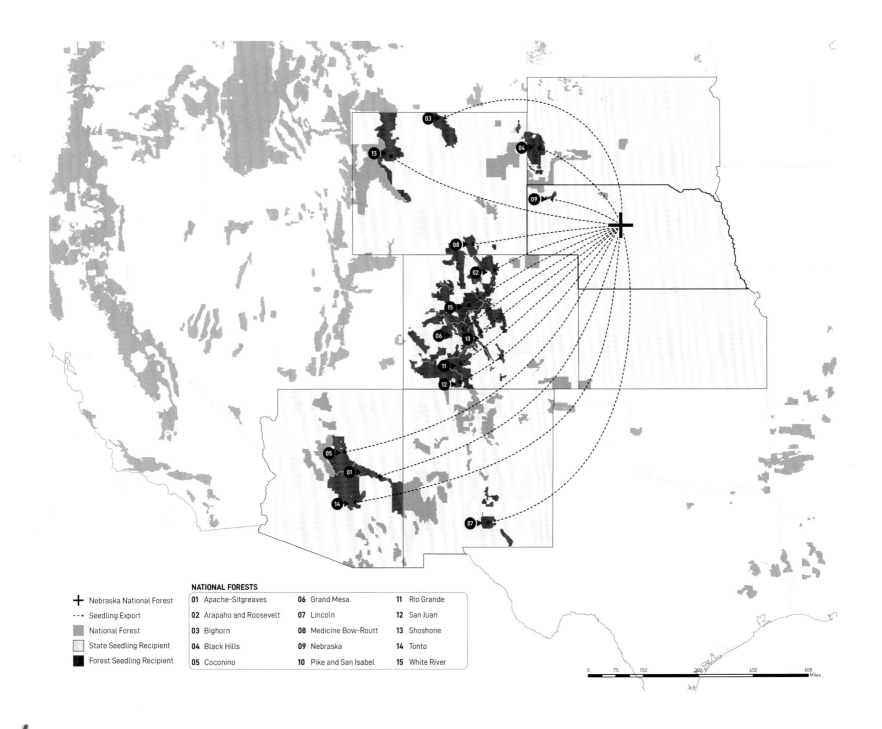

NATIONAL FORESTS

01	Apache-Sitgreaves	**06**	Grand Mesa	**11**	Rio Grande
02	Arapaho and Roosevelt	**07**	Lincoln	**12**	San Juan
03	Bighorn	**08**	Medicine Bow-Routt	**13**	Shoshone
04	Black Hills	**09**	Nebraska	**14**	Tonto
05	Coconino	**10**	Pike and San Isabel	**15**	White River

Nebraska National Forest
Seedling Export
National Forest
State Seedling Recipient
Forest Seedling Recipient

0 75 150 300 450 600
Miles

sowing

The first federal tree nursery was founded on the south bank of the Middle Loup River, to grow seedlings for the adjacent treeless forest reserve. Nursery beds, shade structures, and, later, greenhouses were built to access the abundant water and proximity to the railroad. Not long after the planted trees were established, the Bessey Nursery began producing seedlings through numerous federal programs, including the Kincaid and Clarke-McNary Acts and the Prairie States Forestry Project, and eventually for the Bureau of Indian Affairs reservations in South Dakota and Wyoming. The nursery also distributes seedlings to rural landowners through the Conservation Tree Program. A large portion of the seedlings are kept in cold storage and shipped to national forests in the Rocky Mountain region, for reforestation after increasingly frequent catastrophic wildfires and beetle infestations. While the nursery no longer supports afforestation in the adjacent grasslands, it serves as a seed bank and assists in critical climate change mitigation efforts, helping to develop resilience in native forests. From the beginning it was a high-volume operation, a veritable tree factory, that continues to produce millions of seedlings each year.

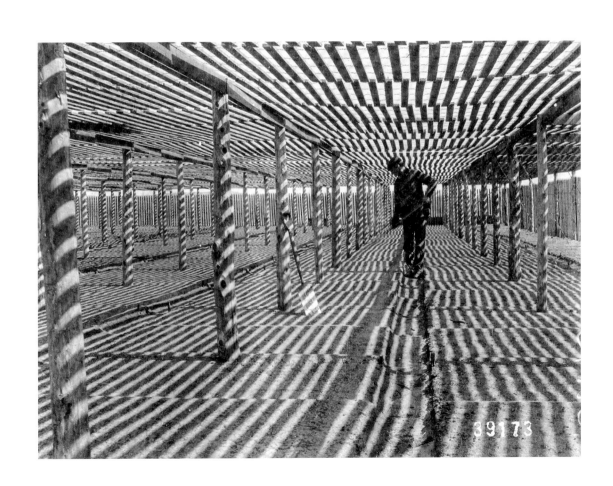

P58. C. A. Scott. *Interior of Seed Beds, Dismal River Forest Nursery, 1903.* Photo courtesy U.S. Forest Service Archives.

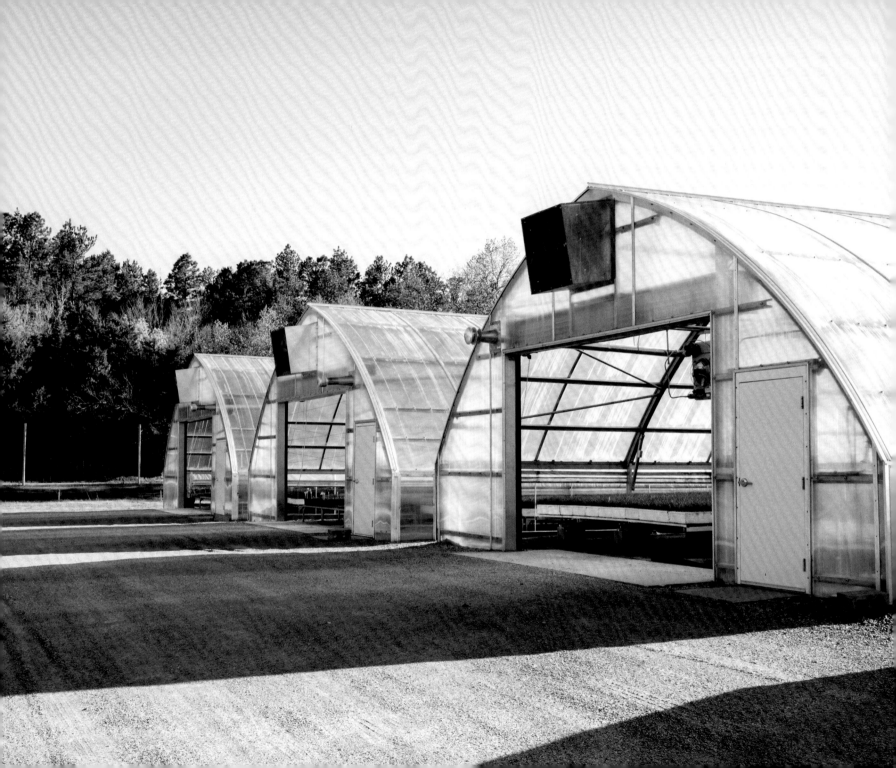

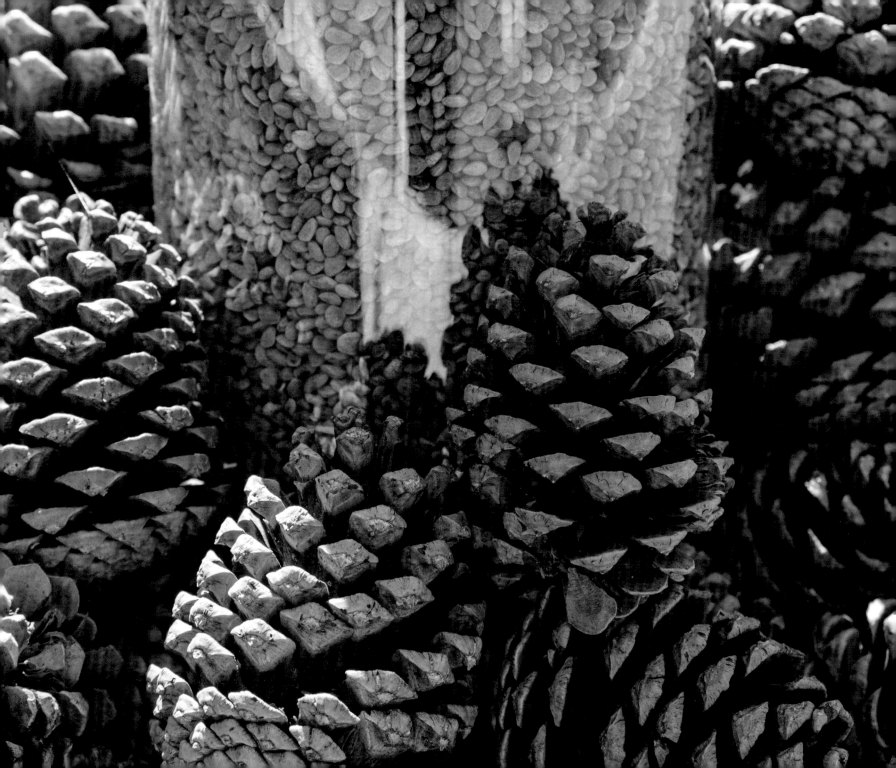

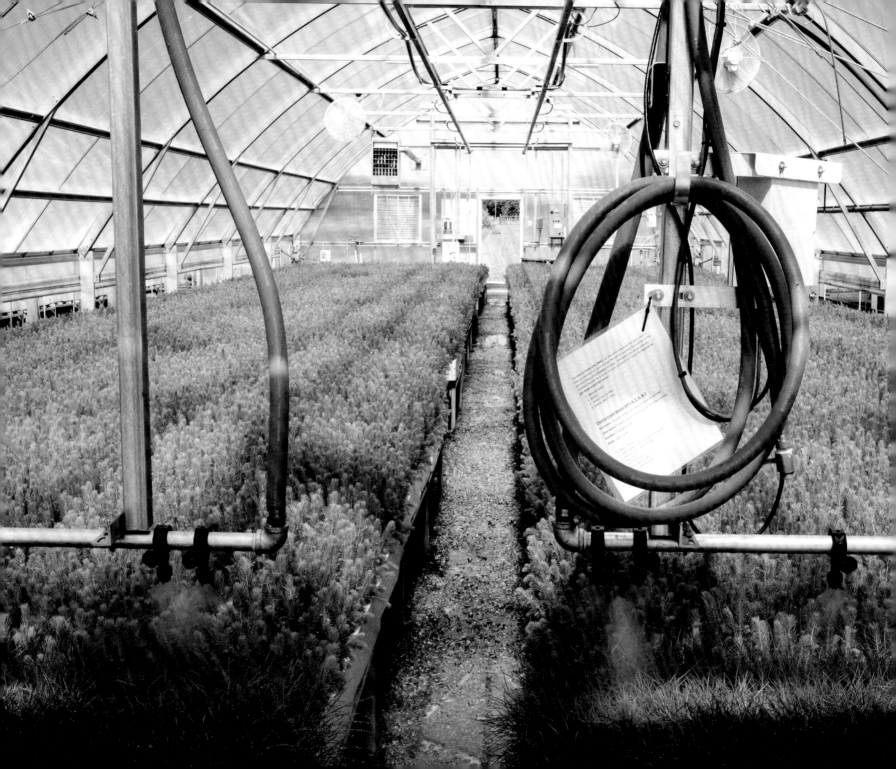

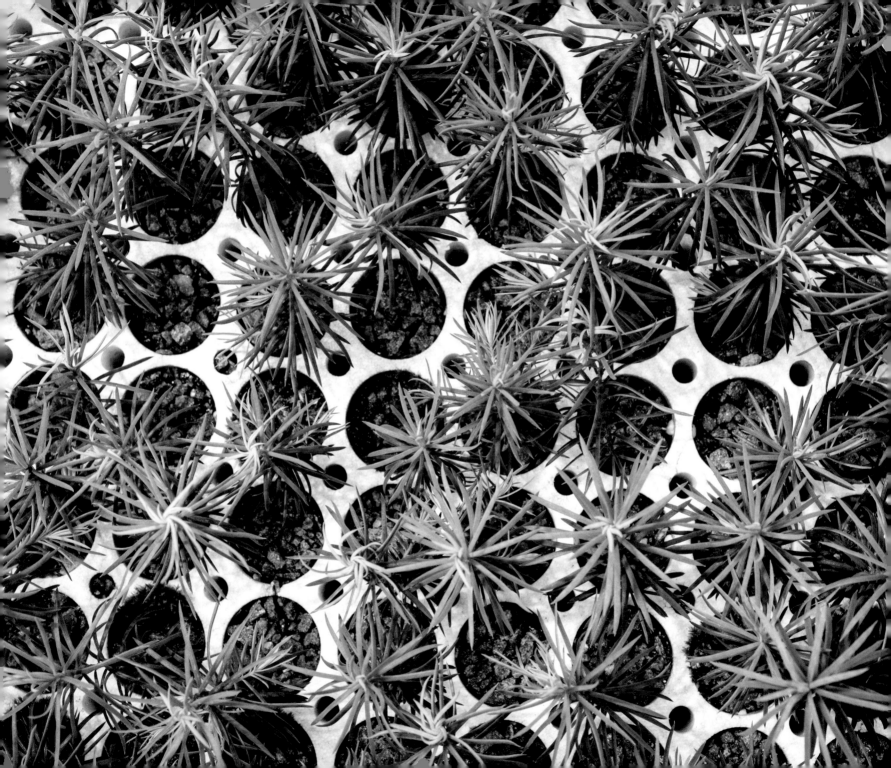

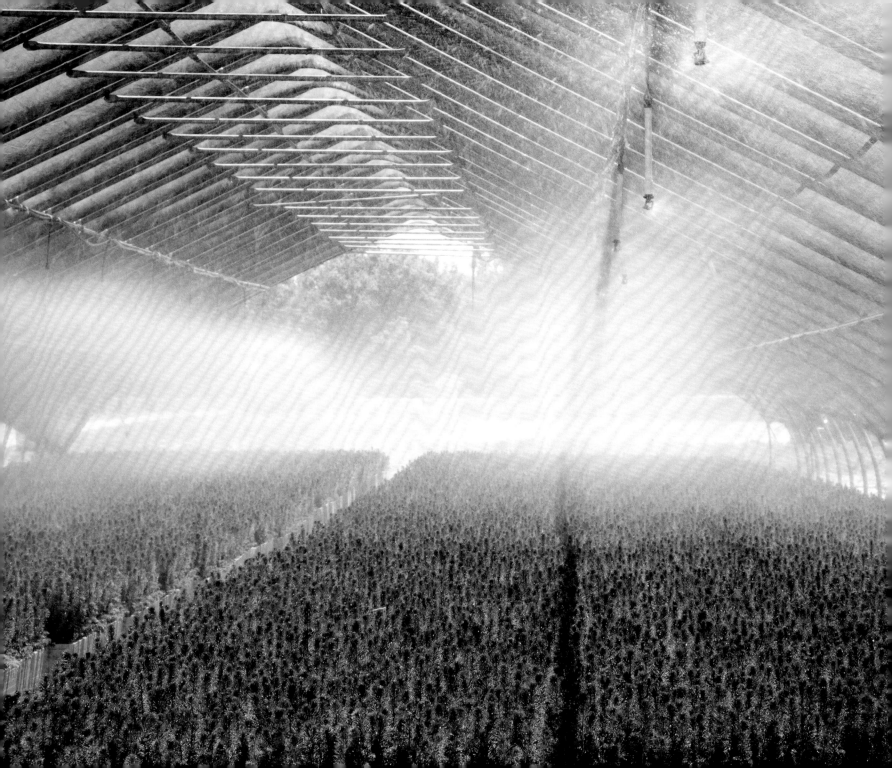

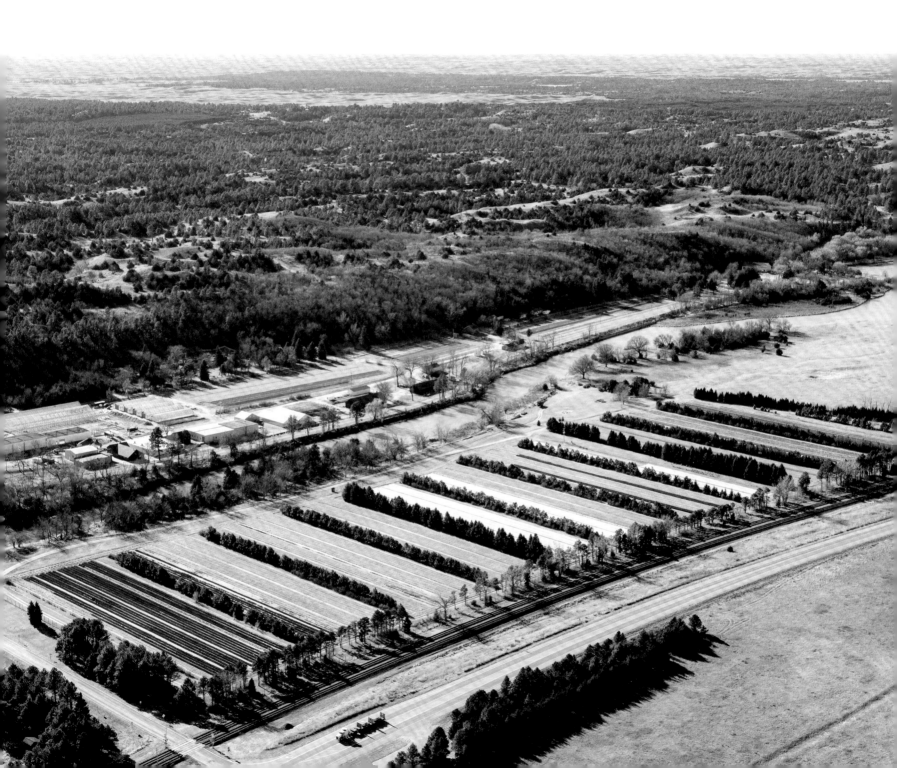

Planting, Fire, Time, and Commingling Species in the Sandhills

ROSE-MARIE MUZIKA

University of Nebraska botany professor Charles Bessey claimed that the sandy, unpromising landscape of the Sandhills was once covered with trees, but his evidence for the claim was scant: the discovery of a single small patch of ponderosa pine and eastern redcedar and the presence of moisture found deep in the sand. A century later, scientists recognized that the climate during the late Pleistocene epoch (approximately twelve to eighteen thousand years ago) may have supported spruce, pine, or a mixed spruce deciduous parkland vegetation.[1] Trees inhabited the Sandhills, which long ago were opportunistic, colonizing landscapes previously too cold and dry to support trees. The "recolonization" of the forests through planting in the early twentieth century could only have occurred through idealistic imagination and intervention, cloaking the landscape in trees with the goal of timber production.

Starting with jack pines dug from the forests of Minnesota, the early "tree planters" of the Sandhills obviously had fire on their minds. Jack pine cones are serotinous, releasing seeds when subjected to the heat of fire, but at the time of this planting, fire was considered an enemy of the forest. The early foresters suggested that the landscape was barren because of fire and bison. The goal of early landscape restoration was to convert the relatively treeless landscape into a forest. Their efforts defied nature, but they were creating a new nature to

replace a landscape assumed to have minimal economic or biological opportunity.

Ponderosa pine, a native tree of western Nebraska, was likely the most successful species of the early afforestation program and it persists well to this day. The evidence of many other species such as Douglas fir and Scotch pine remain, but considering the entire landscape, these trees are dwarfed numerically by eastern redcedar, another native of Nebraska that—left unchecked—will be the landscape's grand successor.

Many of the original trees of over a century ago are gone, but their descendants live on. Regeneration has occurred and over time the forest resembles less a plantation and more a natural system. Disturbance along the way altered the community and contributed to its ability to assume natural processes. In the 1930s a severe drought affected much of the central plains and caused extensive tree mortality. Survivors lived on to regenerate the forest, revealing a form of ecological networks that were developing between unfamiliar trees and a persistent landscape. Ecologists might wonder how ingrained those connections are after this century of growth; many of the connections might include insects, pollinators, herbivores, and the networks that exist below the soil surface.

Current grazing on the landscape reminds the visitor of the role of human activity, as cattle, not bison, are widespread.

Fire represents the disturbance most likely to reconfigure a forest. In 1910 a fire started many miles west of the area, but winds carried it quickly to the forest and caused considerable damage to the young plantings. A more substantial fire occurred in May 1965, when a lightning bolt ignited a yucca in a field of bunchgrass and burned through eleven thousand acres of the planted areas. Surviving trees, notably the jack pine, contributed to restoring that burned landscape, assisted by plantings donated by community groups, local residents, and many others interested in maintaining the forest. By that time many visitors and residents may have imagined that the forest was "natural."

Over its century of forest management, the U.S. Forest Service policies regarding fire have pivoted. Protection was of foremost importance early in the twentieth century and protection from fire remained a priority for decades. Massive fires such as the Pestigo fire in 1871 (in Wisconsin) and the "big burn" in 1910 (across Montana and Idaho) resulted in part from drought conditions and the prevalence of post-logging slash and woody debris. Protecting the

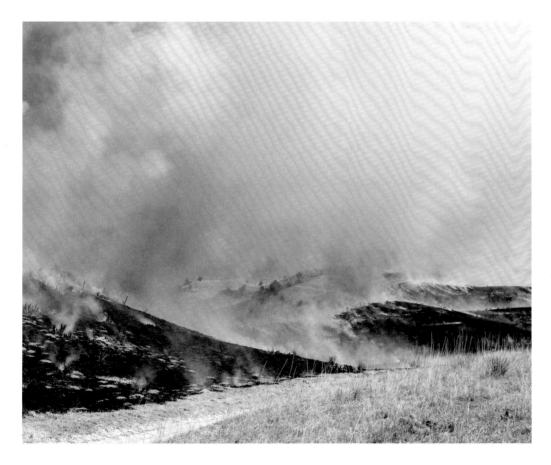

P67. *Signal Hill Prescribed Burn, Grasslands.* Dana Fritz, 2021.

forest and preventing or extinguishing fires occupied the federal agency and cost millions of dollars. The eventual recognition that fire could be a rejuvenating factor for certain species and ecosystems, and that fire can reduce fuel loads, resulted in federal and state land management agencies rethinking their fire prevention policies. Now the use of prescribed fires to promote the health of the forest and prevent deadly fuel accumulation has become common. Many fire management policies guiding operation of public lands include the *use* of fire, rather than only *fighting* fire.

The Nebraska National Forest reflects those changing fire policies. The conviction of fire as the original enemy of the forest has softened, to acknowledging fire as companion of forest management and stewardship. Wildland fires still occur, and prevention remains critical, but the use of prescribed fires is becoming more common on the Nebraska National Forest and Grasslands. With the principal objective of fuel reduction, as well as the desire to eliminate competing or invasive plant species, prescribed burning has become standard practice. Reducing the encroachment of eastern redcedar ranks among the goals of prescribed fire.

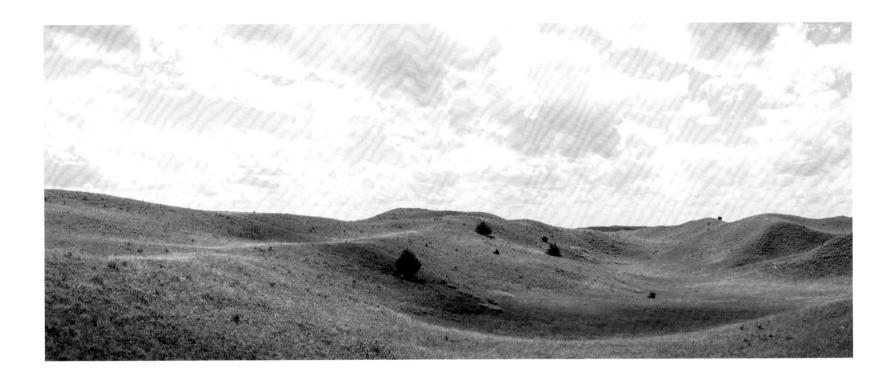

The abundance, development, and persistence of eastern redcedar in the Bessey Ranger District parallel the changing fire policies over the century. Through much of the central plains, eastern redcedar is often the first tree to colonize abandoned agriculture landscapes and its wide ecological amplitude (the ability to grow in wide-ranging environmental conditions) provides the key to its success. Although a native species whose natural distribution reached "two-thirds westward across the State," according Bessey, it successfully spreads across the landscape, particularly across land that is unsuitable for many other species. In the Nebraska National Forest and Grassland, eastern redcedar was planted frequently, and it was also broadcast sown, increasing the possibility of forming very dense stands. Once established, these stands persist. Generally, redcedar is sensitive to fire when young but can resist fire with increasing size and age. During most of the twentieth century fire was extinguished and eastern redcedar flourished. Currently there are decades-old stands of eastern redcedar and small redcedar wooded areas dotting

P68. *Sandhills and Eastern Redcedars.* Dana Fritz, 2019.

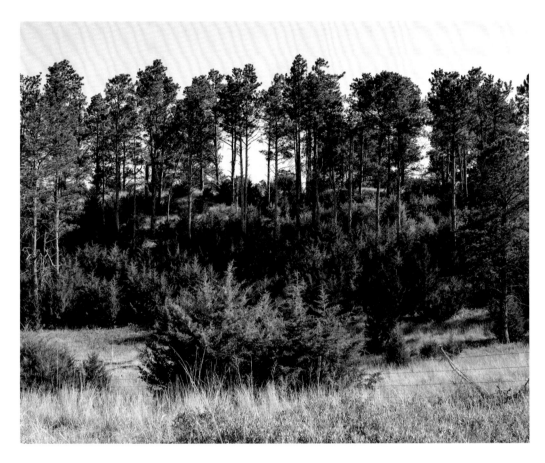

P69. *Encroaching Eastern Redcedars.* Dana Fritz, 2021.

the landscape (photograph 68) whose scattered patterns and inconspicuous structures belie the potential that this small tree has to change ecosystem processes and biodiversity. Once established, a field of eastern redcedar can convert to a wall of eastern redcedar in a mere fourteen years, often preventing other plants from getting established. Hence "cedar thickets" compromise wildlife habitat and limit plant diversity. The forest plantings established over decades provide a seed source that can potentially convert the grassland to an eastern redcedar forest.

Intervention is now required, and prescribed fire management focuses on reducing the dominance of eastern redcedar. The incongruity of spending millions of dollars and hours of physical labor to reduce the spread of this tree, following the decades of planting it, underscores that a forest (natural or planted) is not a brief experiment but requires decades to reach consilience, if it does at all.

In some areas of the forest, eastern redcedar is poised to replace ponderosa pine, because the latter is reaching maturity while the encroaching cedars populate the regeneration layer (see photo 69). This structure represents an altered notion of ecological succession. Two species that rarely cooccur,

combined with an early successional, rapidly grown species (eastern redcedar), replace a later successional species (ponderosa pine), contradicting a classic model of succession. Not only have novel species groups developed—we now see novel processes resulting from this hand-planted forest.

Non-analogue assemblages of plants, animals, fungi, bacteria, and so on are those that may not have existed together previously; these result from a changing environment and are likely to become more common over time. The hybrid Sandhills landscape assemblage of species—some of which never coexisted—might portend the model of vegetation in the future. This now forested landscape resulted from human intervention, not simply a changing environment, but could it become a prototype for future chimeric landscapes and ecosystems?

This portion of the Nebraska National Forest and Grasslands is an improbable story of resilience. Despite various disturbance events, survivors from early plantings developed an internal resilience. Although facilitated and enhanced by subsequent plantings, intrinsic ecological processes provide momentum for the forest to persist. Ghosts of plantations past remain and become increasingly obscured by regeneration of descendants

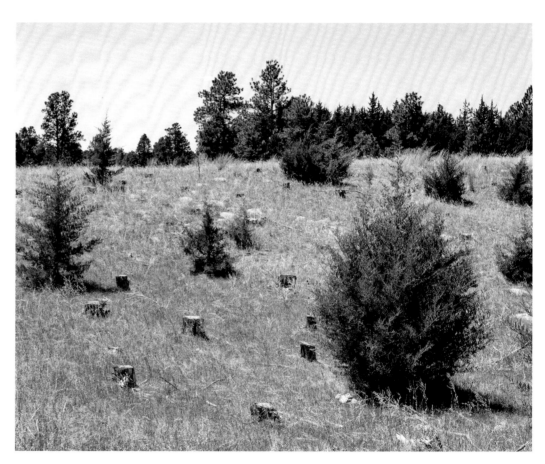

P70. *Eastern Redcedar Stumps.* Dana Fritz, 2021.

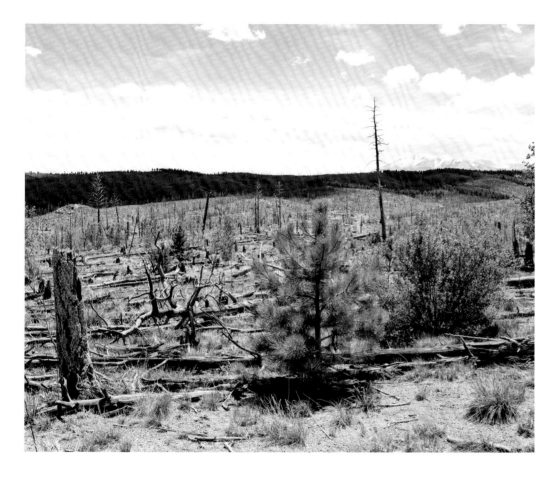

P71. *Bessey Trees Used in Reforestation after the 2001 Hayman Fire in Pike National Forest, Colorado.* Dana Fritz, 2021.

of the earliest plantings (photo 70). In this same landscape the mechanism of future resilience is evident in the Bessey Nursery, where intensive production of trees was also launched early in the twentieth century in the seemingly unproductive Sandhills. Although the earliest plantings of the forest were seedlings and saplings removed from other states as far away as Michigan, Minnesota, and New Mexico, by 1904 thousands of seedlings from the Bessey Nursery were planted. From this impressively complete nursery, seedlings currently revegetate national forests in the western United States lost through fire. The barren landscapes remaining from the aftermath of devastating wildfires across the U.S. West can be brought back to life through the seedlings of the Bessey Nursery, generating a facilitated resilience. With increasing wildfire potential from serious droughts and climatic shifts, the need for nursery stock from the Bessey Nursery becomes more critical and more urgent with each passing year (photo 71).

An important goal of twenty-first-century ecological restoration is to create diverse communities and ecosystems using the natural elements, species, structures, and processes that exist or that can exist on a given landscape. The early-twentieth-century goal of the Nebraska National Forest was to create a

diverse forest from nearly "nothing." On this Sandhills *tabula rasa* the botanists, foresters, and ecologists generated a brew of a variety of species to cover the otherwise unpromising terrain—a novel ecosystem, hitherto unknown. Climatic changes, too, create novel ecosystems, in that some species do not persist under changing conditions, while others flourish and expand. Plant species are particularly vulnerable, owing to their limited vagility, or ability to move or migrate. Animals can create novel communities more readily and "escape" to a more favorable environment. Ideas about assisted migration to facilitate plant species "movement" to more favorable environments might benefit from a close look at the Bessey District. Perhaps it was prescient that Charles Bessey wrote a thirty-seven-page document titled "Plant Migration Studies" in 1905.

This paradoxical landscape is not restoration, but creation. Since there is no ecological, geographic, or functional equivalent, the created landscape challenges the scientific search for unifying themes in ecological and forest systems. But it also provides a reminder of a dynamic and unpredictable nature.

NOTE

1. C. G. Fredlund and P. J Jaumann, "Late Quaternary Palynological and Paleobotanical Records from the Central Great Plains." Kansas Geological Survey Guidebook No. 5 (Lawrence: University of Kansas, 1987).

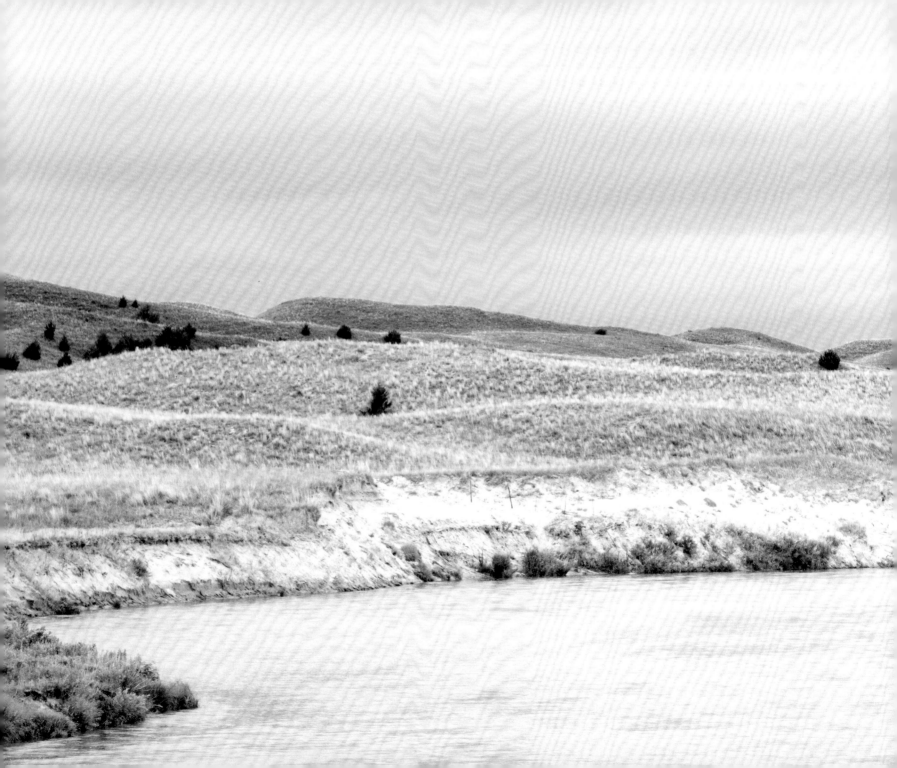

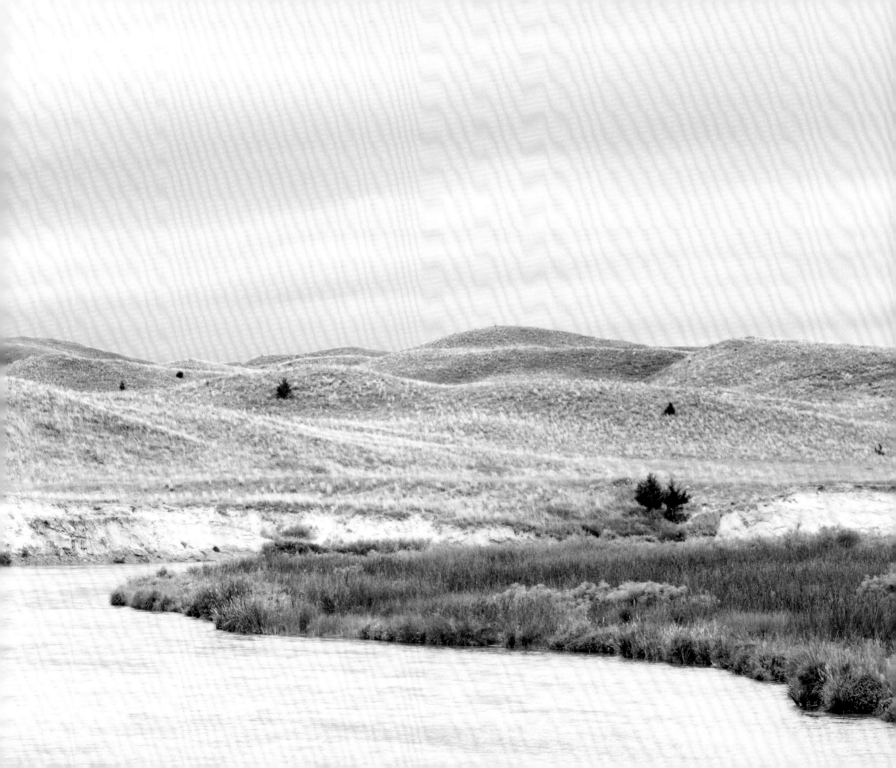

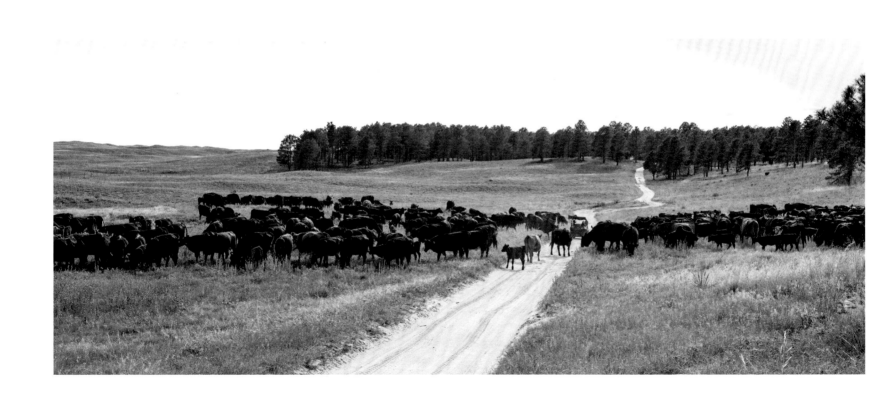

Reenvisioning a Visioned Landscape

REBECCA BULLER

At twenty thousand acres, America's and arguably the Western Hemisphere's (and once the world's) largest hand-planted forest rises as a coniferous evergreen island within the Western Hemisphere's largest stabilized dune field, the relict erg known as the Sandhills of Nebraska. A landscape that mixes cattle, a pine forest, cedars iced blue with berries, and stabilized sand dunes might be an unexpected sight to most global citizens (photo 72). Yet such a scene is familiar to a Sandhills rancher. What once was a botany professor's experiment to see whether pine trees could survive in the Great American Desert, today endures, with living vestiges of the more than century-old experiment.

The cultural and environmental histories of what now constitutes the Nebraska National Forest and Grasslands and Bessey Ranger District embody shifting ideas about land management and land use as well as climate change. Today visitors to the landscape will see the dominant narrative for a visioned landscape that began in the late nineteenth century. My aim, however, is to share a different narrative, a new vision—neither a singular nor a replacement—to offer the concept that hundreds of narratives and experiences of place exist simultaneously, then, now, and in the future. How did this place come to be? Who benefited? Who lost? How have land uses and philosophies of land use changed in this land of many uses?

P72. *Cattle Blocking the Road out of Whitetail Campground.* Dana Fritz, 2021.

Nebraska's Sandhills are a relict erg. Long ago, large volumes of sand that had eroded south from the Black Hills and east from the Rocky Mountains were transported by the ancestral Platte River and deposited as alluvial fill and floodplain alluvium. Eventually, these sand dunes ("erg" desert surface), during a pronounced period of limited precipitation, migrated by the will of aeolian forces. As the climate changed, bringing more regular and plentiful rainfall, midlatitude grassland vegetation also took root, stabilizing the dunes, ceasing migration of the slip faces, and establishing a "relict" on the map. Two major rivers—the Dismal and the Middle Loup—shaped both the area's topography and its ecosystems.

For centuries prior to afforestation, various Indigenous peoples traveled through the area, now known as the Bessey Ranger District. In recent human history these included the Očhéthi Šakówiŋ (Sioux), the Pâri (Pawnees), and the Tséstho'e (Cheyennes). There is scant record that any of these Indigenous nations spent long periods of time here, residing in villages. Other peoples occasionally traveled through, such as when the agricultural Pawnees headed west during their winter and summer bison hunts. Despite the area being sparsely populated, the human impact on the environment still might have been deep due to centuries of these nations' traveling activities, like the use of fire to herd game, cover tracks from enemies' view, and promote forage vegetation growth to help feed their horses. The Pawnees also used fire to burn off trees and brush that might overshadow riparian growths of chokecherry and thickets of wild plum.[1] They managed these thickets along the Middle Loup, gathering the abundant fruit to supplement their diet.[2]

Dispossession of Native lands occurred in the mid- to late-nineteenth century as white settlers moved in. Lands now part of the Bessey Ranger District were taken from the Pawnees in Cession 408, ratified on September 24, 1857, and from the Sioux in Cession 584, ratified on April 29, 1868. The enticement of a "free" 160 acres via the Homestead Act of 1863 and the Timber Culture Act of 1873 helped to bring in outsiders. But with soils and a landscape not ideally suited to agricultural crop development and only a few timber claims being successful, the Nebraska Sandhills did not receive pronounced settlement until the 1904 Kinkaid Act, with its lure of 640-acre homesteads. For years some settlers optimistically and stubbornly fought to demonstrate that these large homesteads could be

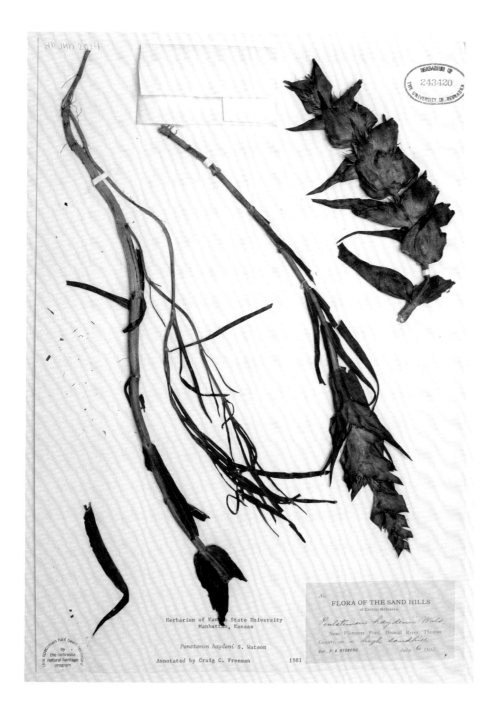

successful row-crop producers. Nonetheless, most Sandhills homesteads eventually proved more productive as large-acreage grassland cattle ranches.

The lands were home to numerous fauna and flora. Common fauna included white-tailed deer, cottontail (rabbits), raptors, and warm- and cool-water fish (such as brook silverside, channel catfish, rainbow trout, and the rare plains topminnow). We can know some of the flora species that grew in these Sandhills mixed-grass prairies and riparian lowland tall-grass prairies before and during forestation via the Charles E. Bessey Herbarium collection. Today, on the University of Nebraska–Lincoln campus, the Nebraska State Museum continues to curate and care for hundreds of thousands of Bessey Herbarium botanical specimens, with some samples more than a century old. Samples of the rare flowering blowout penstemon (*Penstemon Haydenii S. Watson*), the only plant in Nebraska listed as endangered by the U.S. Fish & Wildlife Service, were gathered in

P73. *Penstemon Haydenii S. Watson (Blowout Penstemon), collected Thomas County ne, November 1902.* Photo courtesy Charles E. Bessey Herbarium, University of Nebraska State Museum, University of Nebraska–Lincoln.

Thomas County on July 6, 1893 (see photos 73 and 74). Spines and flowerets of soapweed (*Yucca glauca*) were collected on the Middle Loup River near Thedford on June 19, 1893. Eastern redcedar and prickly pear were secured in the late 1800s. Samples collected throughout the twentieth century include grasses (big bluestem, Indian grass, little bluestem, sand bluestem, and switchgrass); wildflowers (prairie larkspur); trees (hand-planted jack pine and ponderosa pine); and shrubs (leadplant, poison ivy, and sumac).

As a scientific experiment beginning just after the frontier period, the standard narrative of the Bessey Division reads as singular and masculine—stereotypically western—based on themes of competition, Caucasian biography, and progressive science to "improve" nature. Indeed, during and after Indigenous dispossession in the late nineteenth century, populations of European American newcomers to the area largely did not practice effective land conservation. Ideologies infused, in part, by human's dominance over land and independent rogue cowboy culture led to cattle overgrazing the stabilizing vegetation. Portions of sand dunes became exposed once again.[3]

Eager to hold the sands down and "improve the land," scientists led by Charles

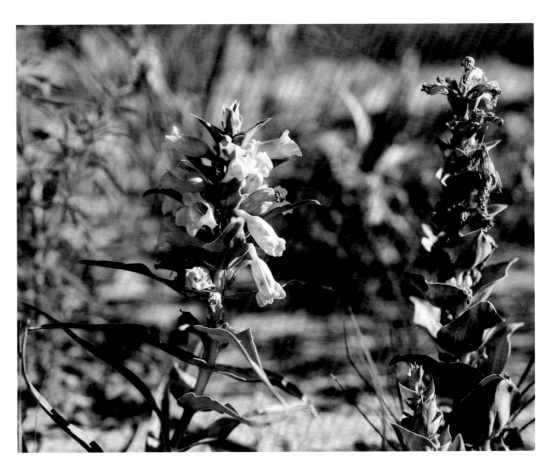

P74. *Blowout Penstemon in a Living Educational Display, Bessey Ranger Station.* Dana Fritz, 2021.

Bessey began arbor investigations to see which trees could grow where. After a successful 1892 trial of hand-planted pine seedlings on the Bruner Ranch in Holt County, experimenters attempted afforestation efforts elsewhere. Ten years later the federal government set aside ninety thousand acres in central Nebraska, establishing the Dismal River Forest Reserve, eventually to be renamed after Bessey. They built a tree nursery, now the oldest managed by the U.S. Forest Service, and commenced planting seedlings. Initial descriptions of the coniferous evergreen seedlings experiment captured the public's pessimism of the perceived folly. Even the first Forest Reserve supervisor said that there were "many disappointments to live down." In his K-16 stapled textbook, entitled *Geography of Nebraska*, George Condra—UNL's first geography professor—referred to the forestry project within his "Methods of Reclamation" chapter: "Reclamation is an important factor in geography, as it makes otherwise worthless lands valuable." He noted that there was "most favorable evidence" that the forestation experiments might be a victory.[4] Indeed they were.

Once the experiment and trees literally took root, surviving for several years, science and man's conquering of land was celebrated a success. Condra noted that the forest created "a desirable change in the appearance of the landscape . . . where once the land was regarded as waste."[5] The international spotlight came when Gifford Pinchot, the first chief of the U.S. Forest Service, highlighted it as "one of the great successful tree-planting projects of the world."[6] Soon a new type of land use followed. Starting around 1920, recreation in various forms became popular.[7]

The dominant vision for the landscape—a standard narrative of the forest being European American, Caucasian, masculine, competitive, and human and science "improved"—lingers today. The competitive, masculine gaze, for instance, is revealed in the contemporary, often-touted claims to fame: world's and America's largest hand-planted forest, oldest tree nursery in U.S. Forest Service, Western Hemisphere's largest dune field. Also manifested are the common activities of conquering the height of the Scott Lookout Tower and difficult terrain.

This standard narrative is continued in many land uses, especially hunting and ATVing: both by the activities and the embodiment of those who engage in them. As practiced by most visitors, the spaces are predominantly white, heterosexual, binary, masculine, and of the nuclear family unit. Multiple outdoor recreation opportunities

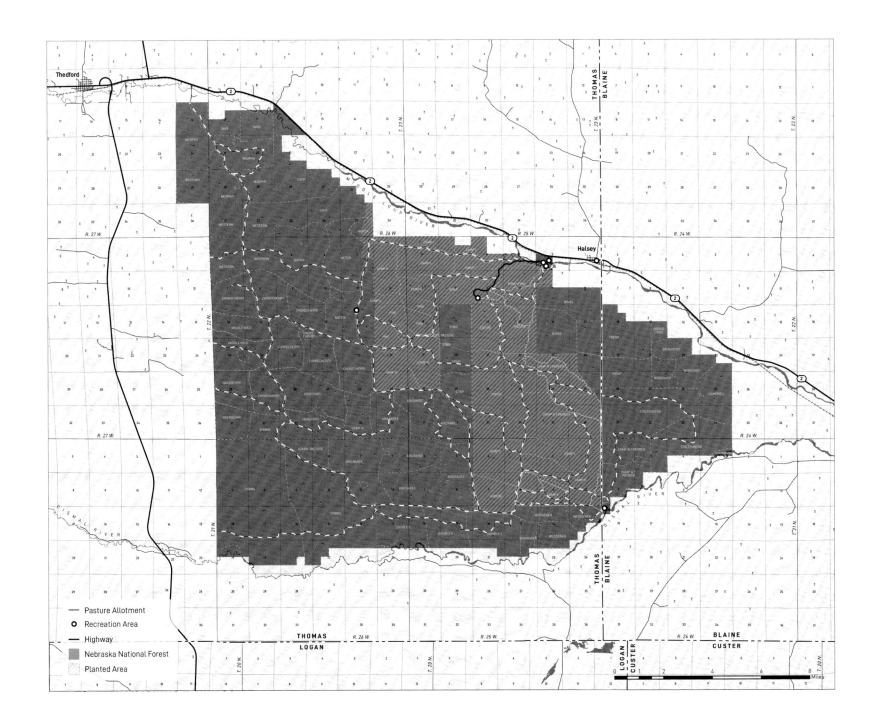

Thedford

THOMAS
BLAINE

Halsey

MIDDLE LOUP RIVER

DISMAL RIVER

DISMAL RIVER

THOMAS
BLAINE

THOMAS
LOGAN

LOGAN
CUSTER

THOMAS
BLAINE

BLAINE
CUSTER

Pasture Allotment
Recreation Area
Highway
Nebraska National Forest
Planted Area

0 1 2 4 6 8
Miles

P75. *Dismal River and Dune with* ATV. Dana Fritz, 2020.

exist, but rarely do you see anything other than (with a nod to Carolyn Finney) white faces in white spaces. If family units are present—camping, fishing, wading, ATVing—they are portrayed and embodied as heterosexual, gender binary, nuclear families. Youth environmental and outdoor leadership education identities follow suit, such as through females leading and training up youth via the State 4-H Camp. Common are amateur YouTube videos of the place. One regular theme is flashpacking and tropophiliacs' novice welcome/tour videos. Heterosexual masculinity is especially celebrated in YouTube videos and outdoor recreation: videos abound of Father's Day weekend excursions by sons and fathers, male buddies bonding adventures of hunting, horseback riding, and UTV trips; or young male riders with staged cameras and GoPros.

But this place is an island, an experiment, an experience, an escape, and an oasis. Masculine dominance has not always been the rule. For generations women have worked at Bessey, planting, weeding, and packing seedlings (photographs 76 and 77). This included work resulting from the Clarke-McNary Act of 1924, which increased tree production for shelterbelts and reforestation. Recent Bessey leadership has

often been female, including forest ranger-managers, forest supervisors, and other USFS administrators.

This forest is both a land of many uses and an increasingly inclusive entity that cares for the land and serves the people. In the past, present, and future, humans and more-than-humans simultaneously interpret and value it in different ways. As so many geographers have reminded us, there are various ways people experience place. Perception is reality. Everyone experiences their own reality, their own narrative. Some are similar to others; while a handful are more toward the spectrum's end of unique. Likewise, there are both numerous definitions of landscape *and* multiple axioms for reading landscapes and texts. As Terry Tempest Williams, an informal geographer in her own right, notes in her work *Erosion*, "none of us see landscape the same."

There are multiple flora and fauna uses, interpretations, illuminations, and gendered landscapes of the forest. For some, sense of community (with others, with place, with aspects of place in the flora, fauna, memory, romantic ideal past, present, future) this community is a pull factor.

At this forest there are symptoms of the condition of topophilia, or a love of place.

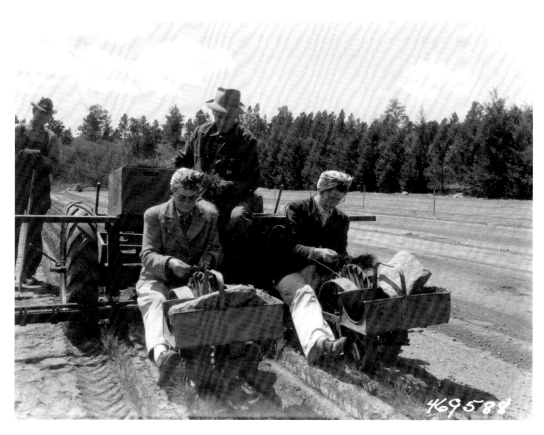

P76. *Women Planting Trees, Bessey Nursery*, n.d. Photo courtesy U.S. Forest Service Archives.

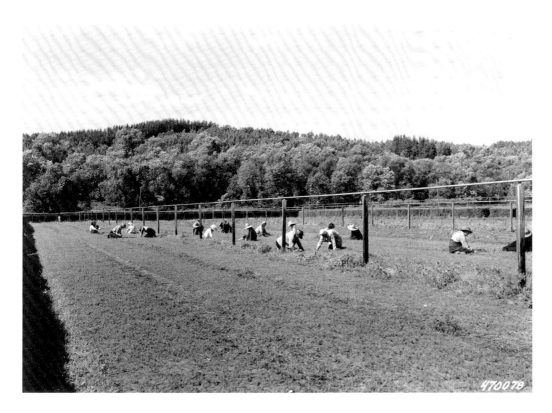

P77. Jay Higgins. *Nursery Weeding Crew Weeding in First Year Seedlings.* Crew consists largely of local women and high school girls who make spending money in this manner and enjoy doing the work. 1952. Photo courtesy U.S. Forest Service Archives.

Some humans, who do not take part in the standard narrative but soak in the place slowly, quietly, intentionally, love the place so much that they will purchase a 4-wheel drive vehicle to enable them to more fully and regularly be in place. Indeed, this sense of community is a sort of chicken-and-egg dilemma with topophilia. Which comes first? Perhaps it, too, varies. Perhaps it doesn't matter. As Williams writes, "To belong to a place and to a group of people saves our lives. Without that we lose sight of this precious gift called life."[8]

This forest can be restorative to humans and more-than-humans. Today the Bessey Nursery grows millions of seedlings annually, shipping them out to the Rocky Mountain Division of the U.S. Forest Service to help both conservation and reforestation efforts following climate change–induced disasters like insect infestations and catastrophic wildfires. The seedlings also are sent to the state's natural resource districts to be used in soil, flora, and fauna conservation efforts in the form of windbreaks, shade trees, and habitat plantings.[9]

The forest also was restorative for an albino porcupine that was hit by a car and nearly killed. Local biologists, tourists, and then Facebook, news outlets, and *National*

Geographic photographer Joel Sartore took note, eventually relocating the porcupine to a wildlife rehab and affectionately naming the animal Halsey, after the town near the forest.

The forest can be restorative figuratively for humans. There is a beauty, a peace, excitement, a rejuvenation in the quiet, in the unexpected. Some come to escape nature-deficit disorder. Those who prefer to experience a place slowly—via kayaking, walking, bird-watching, and other mindfulness activities—very much enjoy the place, often solitarily.

For many, especially during COVID's travel restrictions, the wonder of this place provided the opportunity to forest bathe and refill resilience tanks. As Williams has noted, for some an alternative way of experiencing place is for those who go intentionally, slowly, where "time is measured in increments of awe."

This place, this forest, is an island, an experiment, an experience, an escape, and an oasis.

As a reenvisioning of a visioned landscape, questions with subjective, deeply intertwined answers remain. How did this place come to be? Who benefited? Who lost? Who constitutes the who, both human and more-than-human? How do these stories and attributes compare and contrast within the past, the present, the future? What might be future uses? What does resilience in a changing climate look like? With the increasing importance of preserving grasslands and forests and balancing biodiversity both for carbon sequestration and climate change mitigation, what are the possible futures that ensure success? Of these, what are the various intricate plots that determine which are probable and which are not? The answers to these complex questions vary, depending upon when, where, and who is asking..

NOTES

1. Royal S. Kellogg, *Forest Belts of Western Kansas and Nebraska*, US Department of Agriculture Bulletin no. 66 (Washington DC: U.S. Forest Service, 1905).

2. Richard White, *The Roots of Dependency: Subsistence, Environment, and Social Change among the Choctaws, Pawnees, and Navajos* (Lincoln: University of Nebraska Press, 1988), 163–67.

3. John P. Husmann, "'A Rare Garden Spot': A History of the Nebraska National Forest, 1900–65," Master's thesis, University of Nebraska–Lincoln, 1998, 4–9.

4. George Evert Condra, *Geography of Nebraska* (Lincoln: University Publishing, 1914), 160.

5. Condra, *Geography of Nebraska*, 167.

6. Donald R. Hickey, Susan A. Wunder, and John R. Wunder, *Nebraska Moments* (Lincoln: University of Nebraska Press, 2007), 159.

7. Husmann, "A Rare Garden Spot," 53–72.

8. Terry Tempest Williams, *Erosion: Essays of Undoing* (New York: Sarah Crichton, 2019), 10.

9. Ariana Brocious, "Keeping Nebraska's Hand-Planted Forest Healthy," NET News, NET Nebraska, September 29, 2016, http://netnebraska.org/article/news/1042714/keeping-nebraskas-hand-planted-forest-healthy.

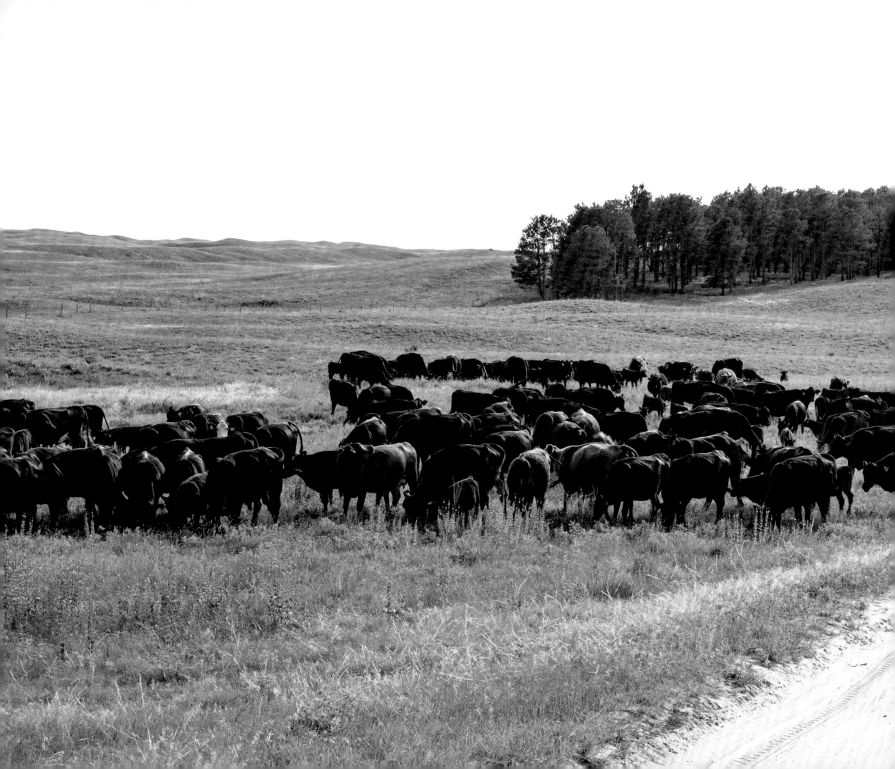

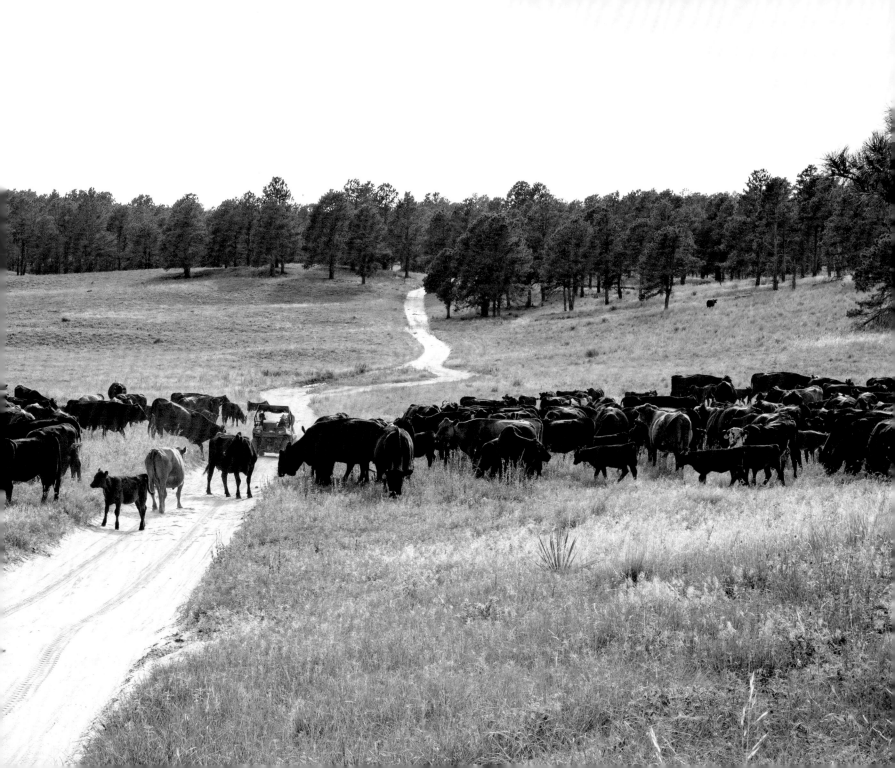

Epilogue

In 2017 the weathered trapezoidal sign with the iconic mid-twentieth-century logotype at the forest entrance on Highway 2 read "Nebraska National Forest." While accurate and succinct, for years it has prioritized the trees. In 2019 the sign was replaced by one that reads "Nebraska National Forests and Grasslands," a more expansive preview of what a visitor will encounter there. Yet, likely for the sake of brevity, both signs omit mention of Bessey Nursery, without which this forest could not have arisen from the formerly treeless forest reserve. Although perhaps just a perfunctory update, the new sign seems symbolic of the U.S. Forest Service's more recent focus on the equal and intrinsic value of both forests and grasslands, the unique combination of which comprise this hybrid landscape.

Gallery

Ponderosa Pine and Sandhills
Afforestation was limited to specific areas that left large sections of grassland intact.

Forest Edge
These trees are at the southern edge of the planted areas near the Dismal River.

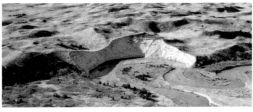

Blowout and Middle Loup River
This exposed area of sand caused by wind and erosion reveals the true height of the dunes and the thin layer of vegetation holding them in place.

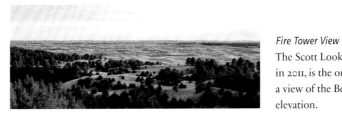

Fire Tower View
The Scott Lookout Tower, built in 1944 and renovated in 2011, is the only fire tower in Nebraska and provides a view of the Bessey Ranger District from a fifty-foot elevation.

Dismal Riverbed
The Dismal River runs cool and fast, fed by springs from the Ogallala, or High Plains, Aquifer.

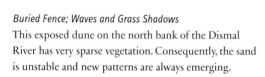

Sandhills near Thedford Airport; Dismal Riverbank
Wave patterns in the sand dunes mirror the smaller-scale patterns on the sandy riverbed.

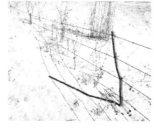

Buried Fence; Waves and Grass Shadows
This exposed dune on the north bank of the Dismal River has very sparse vegetation. Consequently, the sand is unstable and new patterns are always emerging.

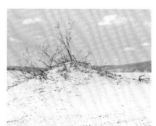

Sand Dune Encroaching on Grasslands;
Tenuously Stabilizing Vegetation
South winds are spreading this dune into the grasslands.

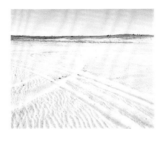

Dune Tracks 1; Dune Tracks 2
The Bessey OHV Trail System includes thirty-six miles of trails and is one of the few public motorized riding trails in Nebraska. The open dune on the Dismal River is part of this system and is heavily used by off-highway vehicles.

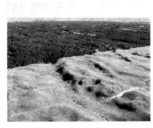

Row Crop Pines; Fire Break
These aerial views reveal the varying densities of the planted areas as well as the mile-wide fire break.

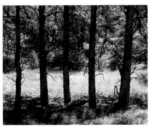

Pine Row; Pine Shadows
Some areas along the hiking trail include vestigial order from the original row crop planting.

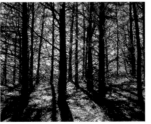
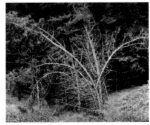

Eastern Redcedar Thicket; Leaning Trees
Eastern redcedars were planted so tightly they held each other up and crowded out all other vegetation. Trees at the end of this row had no such support and may be leaning from a heavy snowfall.

Row Planting; Planted Pines and Invading Eastern Redcedar
Ponderosa pines naturally drop their lower branches, which protects their crowns from fire but also opens up the forest floor to invasive eastern redcedar.

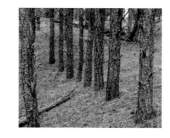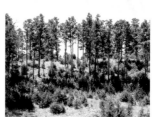

Thinning Boundary; Burn Pile
Trees have been removed up to this thinning boundary sign to leave fire breaks. The cut trees are stacked into piles that will eventually be burned or sold for mulch.

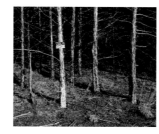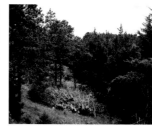

Eastern Redcedar Stumps; Culled Eastern Redcedars
Management on the Bessey Ranger District has shifted from afforestation to grassland restoration. This requires removal of invasive eastern redcedar trees that have encroached on grassland areas.

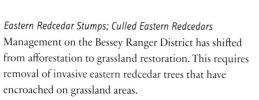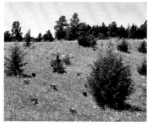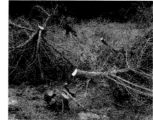

Fuel; Fuel (detail)
Mechanical thinning for fire mitigation results in enormous piles of trees and brush that must be burned or sold for mulch.

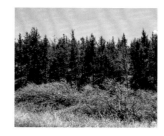

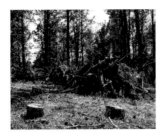 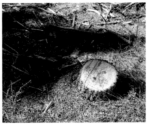

Fire Mitigation; Fresh Stump
This area of dense trees near a campground is being thinned for fire mitigation. Small brush piles will be moved into larger piles to be safely burned.

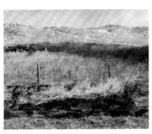 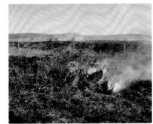

Signal Hill Prescribed Burn (detail), Smoldering Yucca
The objectives of this April 2021 prescribed burn were to kill eastern redcedar trees less than three feet tall, consume one hour fuels, and remove dead material from the ground to encourage new growth of grass and forbs. Yucca continue to smolder after the fire has moved through.

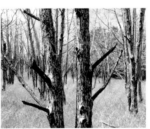 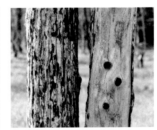

Burned Eastern Redcedars; Burned Eastern Redcedars (detail)
This thick stand of planted eastern redcedar burned in the 2012 Camp 5 Fire that started from a lightning strike and burned over a thousand acres of forest and grassland. The Bessey Ranger District was already under Stage II Fire Restrictions, which are set during high to extreme fire danger.

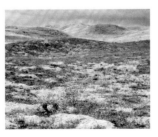 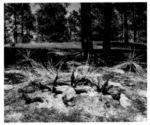

Grassland Prescribed Burn + Three Weeks;
Forest Prescribed Burn + Three Weeks
Three weeks after these April 2021 prescribed burns, new growth is visible. The lighter areas on the horizon are outside the burn area and still have light-colored dead grass. Blackened yucca are sprouting new leaves.

Low-Intensity Burn; Moderate-Intensity Burn
This low-intensity prescribed fire burned grasses, fallen branches, and shrubs on the forest floor but left the canopy intact. The medium intensity 2012 Camp 5 Fire reached higher into the trees, killing some, but many recovered if more than 50 percent of their needles did not burn.

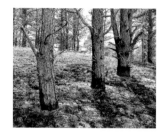 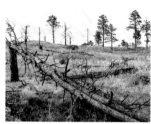

Fallen Tree; Forest Floor after Fuel Removal
A fallen tree is buried in pine needles, which take an average of seven years to decompose. Mechanical fuel removal leaves a thin new layer of debris on the forest floor.

Decaying Pines; Open Trunk
Bark falls off a dead tree after the thin layer of living cells under it is gone. This makes way for insects and fungi to decompose the wood.

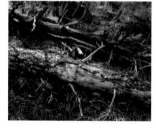

Decaying Roots; Insect Holes
Roots are exposed at the base of decaying trees.

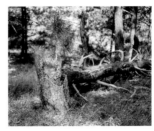

Decaying Pine among Eastern Redcedars; Pine Sapling
The pine planted areas of the Bessey Ranger District now include self-sown eastern redcedars, ponderosa pines, and poison ivy. Fallen trees create protection for new saplings.

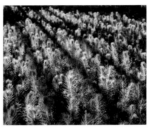

Greenhouses and Forest; Spruce Seedlings
Seedlings for reforestation are grown at an industrial scale in Bessey Nursery greenhouses adjacent to the planted forest.

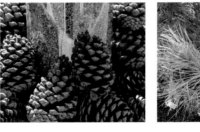

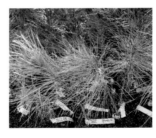

Cones and Seeds; Ponderosa Pine Seedlings
Cones with seeds are collected from the areas where the saplings will be planted, ensuring higher survival rates.

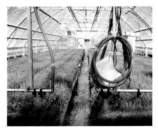

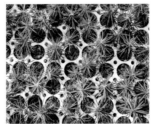

Greenhouse Irrigation Hose; Seedling Containers
Millions of seedlings are grown and packed annually at the Bessey Nursery. Seedlings are kept dormant in cold storage until their destination forest requests shipment.

Greenhouse Irrigation; Bessey Nursery
and Hand-planted Forest
The Bessey Nursery planting beds and greenhouses line
the banks of the Middle Loup River adjacent to the
Bessey Ranger District of the Nebraska National Forest.

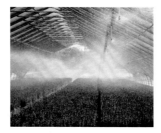 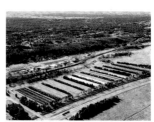

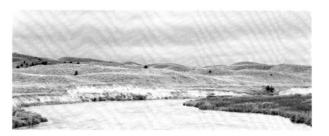

Middle Loup River
The shallow Middle Loup River winds through the
Sandhills, fed by springs from the massive Ogallala
Aquifer below, and runs along the northern boundary of
the Bessey Ranger District.

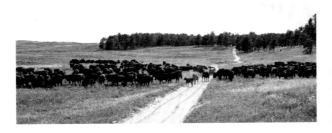

Cattle Blocking the Road Out of Whitetail Campground
Cattle grazing has been an integral part of the Bessey Ranger District management plan since the early twentieth century.

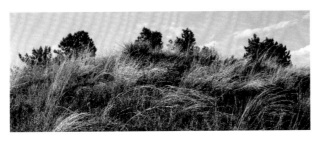

Grassland Forest Ecotone
The priorities of Bessey Ranger District management have shifted from afforestation to grassland restoration, recognizing the native ecosystems that preceded the forest reserve.

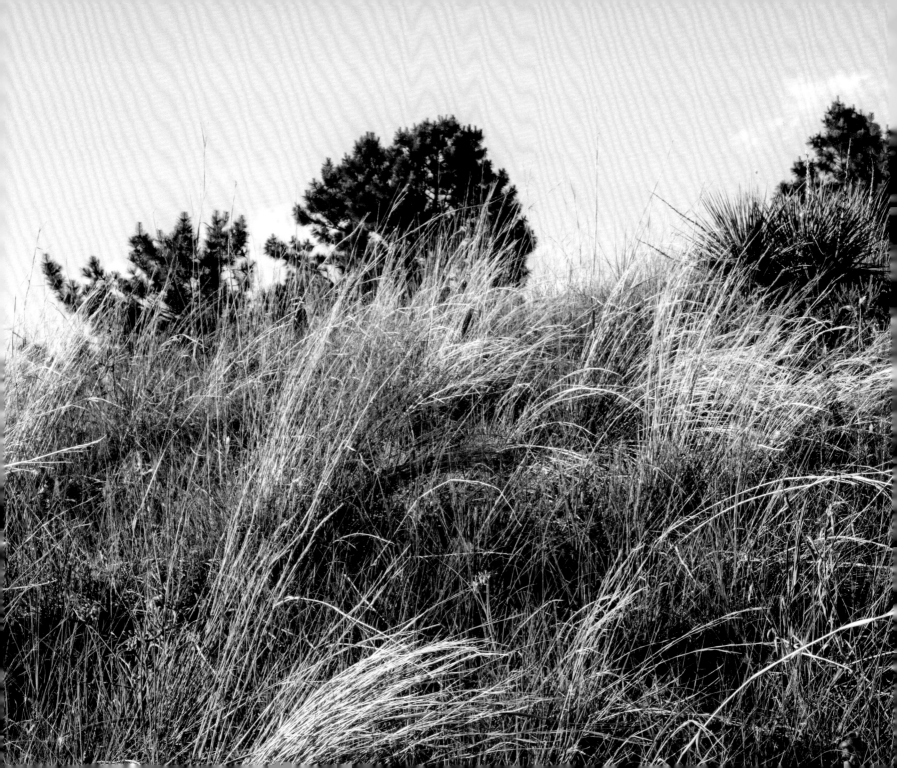

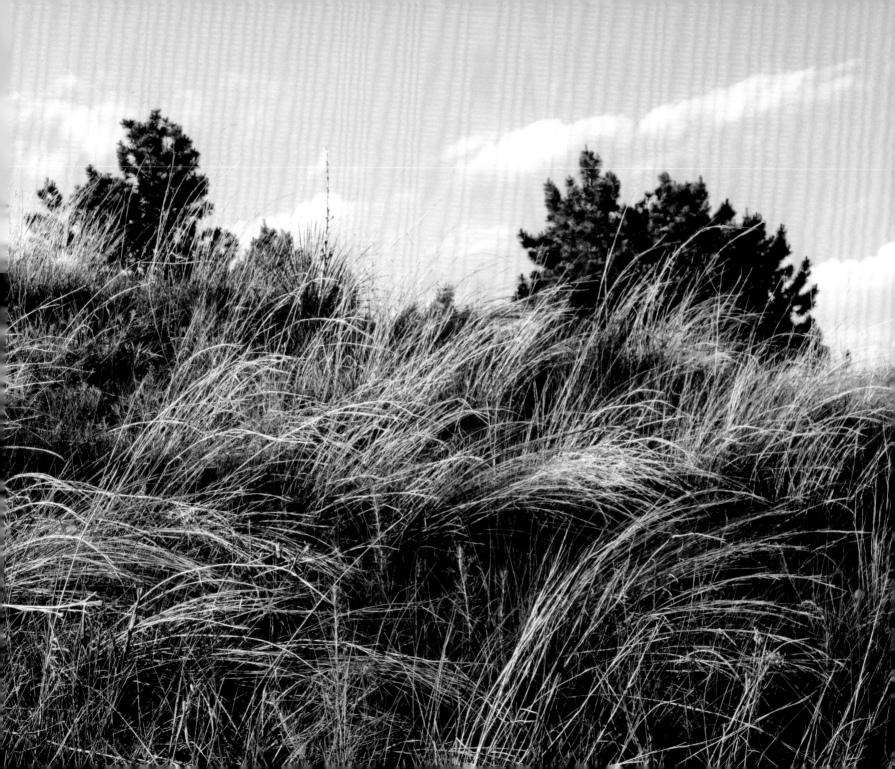

ACKNOWLEDGMENTS

This book was formed and reformed over five years with the cooperation and support of many. My deepest gratitude goes to the U.S. Forest Service staff at the Bessey Ranger District and Nursery, especially District Ranger Julie Bain and Nursery Manager Richard Gilbert, whose patience with me and dedication to their work are unmatched; Todd Duncan and Duncan Aviation, for the welcome new perspective on this hybrid landscape; FujiFilm US, for lending cameras and lenses in 2020; the Environmental Photographers Collective members—Marion Belanger, Margaret LeJeune, Judy Natal, Martina Shenal, and Terri Warpinski—whose critical eyes and minds inspire me and sharpen my vision.; my superb contributors—Katie Anania, Becky Buller, Salvador Lindquist, and Rose-Marie Muzika—for bringing their passion, insight, and expertise to this collaboration; the University of Nebraska–Lincoln's Office of Research and Economic Development Arts and Humanities Research Enhancement Grant and the Hixson-Lied College of Fine & Performing Arts Faculty Grants, without which a book like this would not be possible; Dave Wedin, professor in plant and ecosystem ecology at the University of Nebraska–Lincoln's School of Natural Resources, for his careful review and exuberant bounty of information; University of Nebraska Press executive editor Clark Whitehorn and editor in chief Bridget Barry, for their knowledge, direction, and confidence in my vision for the book; and Larry Gawel, for unconditional love, support, assistance, reality checks, and partnership since 1993.

FURTHER READING

Christopherson, Susan. "On Being Outside 'the Project." *Antipode* 21, no. 2 (1989): 83–89.

Finney, Carolyn. *Black Faces, White Spaces: Reimagining the Relationship of African Americans to the Great Outdoors*. Chapel Hill: University of North Carolina Press, 2014.

Gardner, Robert. "Constructing a Technological Forest: Nature, Culture, and Tree-Planting in the Nebraska Sand Hills." *Environmental History* 14, no. 2 (April 2009): 275–97.

Gregory, Derek. "Imaginative Geographies." *Progress in Human Geography* 19, no. 4 (1995): 447–85.

Haraway, Donna Jeanne. *Staying with the Trouble: Making Kin in the Chthulucene*. Durham NC: Duke University Press, 2016.

Haskell, David George. *The Songs of Trees: Stories from Nature's Great Connectors*. New York: Viking, 2017.

Hickey, Donald R., Susan A. Wunder, and John R. Wunder. *Nebraska Moments*. Lincoln, Nebraska: University of Nebraska Press, 2007.

Kimmerer, Robin Wall. *Braiding Sweetgrass: Indigenous Wisdom, Scientific Knowledge, and the Teachings of Plants*. Minneapolis, Minnesota: Milkweed Editions, 2013.

Knobloch, Frieda. *The Culture of Wilderness: Agriculture as Colonization in the American West*. Chapel Hill: University of North Carolina Press, 1996.

Knopp, Lisa. "Far Brought." In *The Nature of Home: A Lexicon of Essays*. Lincoln: University of Nebraska Press, 2004.

Kolbert, Elizabeth. *Under a White Sky: The Nature of the Future*. New York: Crown, 2021.

McIntosh, Charles Barron. *The Nebraska Sand Hills: The Human Landscape*. Lincoln: University of Nebraska Press, 1996.

Olstad, Tyra A. *Zen of the Plains: Experiencing Wild Western Places*. Denton TX: University of North Texas Press, 2014.

Orth, Joel J. "Directing Nature's Creative Forces: Climate Change, Afforestation, and the Nebraska National Forest." *Western Historical Quarterly* 42 (Summer 2011): 197–217.

Overfield, Richard A. "Trees for the Great Plains: Charles E. Bessey and Forestry." *Journal of Forest History* 23, no. 1 (January 1979): 18–31.

Peters, Greg M. *Our National Forests: Stories from America's Most Important Public Lands*. Portland: Timber, 2021.

Pool, Raymond J. "Fifty Years on the Nebraska National Forest." *Nebraska History* 34 (1953): 139–79.

Schwartz, Joan M., and James R. Ryan, eds. *Picturing Place: Photography and the Geographical Imagination*. London: IB Tauris, 2003.

Simard, Suzanne. *Finding the Mother Tree: Discovering the Wisdom of the Forest*. New York: Alfred A. Knopf, 2021.

Walsh, Thomas R. "The American Green of Charles Bessey." *Nebraska History* 53 (1972): 35–57.

Williams, Terry Tempest. *Erosion: Essays of Undoing*. New York: Sarah Crichton Books/ Farrar, Straus and Giroux, 2019.

———. *The Hour of Land: A Personal Topography of America's National Parks*. New York: Sarah Crichton /Farrar, Straus and Giroux, 2016.

CONTRIBUTORS

DANA FRITZ uses photography to investigate the ways we shape and represent the natural world in cultivated and constructed landscapes. Her work has been exhibited and collected internationally and she has held artist residencies at locations known for their significant cultural histories and gardens or unique landscapes, including Biosphere 2 and Homestead National Historical Park. Her monograph, *Terraria Gigantica: The World under Glass,* was published by University of New Mexico Press in 2017. She is currently Hixson-Lied Professor of Art at the University of Nebraska–Lincoln, where she is also a fellow at the Center for Great Plains Studies.

KATIE ANANIA is an art historian who specializes in queer and ecofeminist art histories in the long twentieth century, particularly intersecting discourses on food, labor, and graphic representation. Her first book project, *Out of Paper: Drawing, Environment, and the Body in 1960s America,* investigates large-scale performance drawings that connected the body with its surrounding ecosystem. Her second book project traces the use of food as a material in hemispheric feminist artworks of the 1970s. She is an assistant professor of art history at the University of Nebraska–Lincoln.

REBECCA BULLER is a cultural and histori-
cal geographer, with interests in the Great
Plains, American West, Iceland, genders'
studies, geographic inquiry, experiential
education, and human trafficking. At the
University of Nebraska–Lincoln she is
an associate professor of practice in the
geography program and a fellow at the
Center for Great Plains Studies. Buller is
steeped in place and afflicted by adventure,
nature, and topophilia. She grew up in the
Nebraska Sandhills, near Bessey's origi-
nal test plot, and educates leaders within
UNL's Bessey Hall and at other locations.

SALVADOR LINDQUIST is an assistant
professor of landscape architecture at
the University of Nebraska–Lincoln.
Lindquist is a founding partner of
Context Collaborative, a spatial practice
that explores multiscalar urban contexts
through design research. His area of
research is in spatial justice, co-design,
and mapping, with a particular interest in
postindustrial landscapes, shrinking cities,
and marginalized communities.

ROSE-MARIE MUZIKA, director of sci-
ence at the Carnegie Museum of Natural
History in Pittsburgh, Pennsylvania, over-
sees the museum's research staff as well as
the management and care of collections.
She is professor emerita at the University
of Missouri's School of Natural Resources
and a board member of the Forest History
Society. Muzika's research emphasizes
disturbance ecology of forests, including
natural and anthropogenic disturbances
due to fire, species introduction, and cli-
mate change.